A WORLD OF CHANGE

A WORLD OF CHANGE
A Book of Portraits

by Lynda Greer

LONGSTREET PRESS
Atlanta, Georgia

Thank you, Ben, for your encouragement and support.
I couldn't have done this without you.

**The publication of this book was made possible
by the support of Invacare Corporation.**

Published by
LONGSTREET PRESS, INC.
2140 Newmarket Parkway
Suite 118
Marietta, GA 30067

Printed in the United States of America

1st printing 1992

Library of Congress Catalog Card Number: 92-71795

ISBN 1-56352-046-X

This book was printed by Data Reproductions Corporation, Rochester Hills, Michigan.
The text was set in Avant Garde.

Book design by Jill Dible.
Jacket design by Semion Shkolnik.

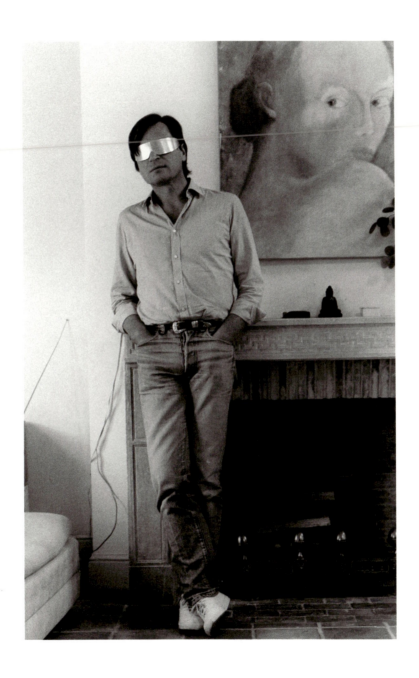

This book is dedicated to Hugues de Montalembert,
whose personal experience and creative vision directed me to this project.

FOREWORD

Approximately 43 million Americans—roughly one-sixth of the population—have some form of disability. Despite their disabilities, these people have the same likes and dislikes as anyone else. They hold jobs, buy cars, have children, take vacations, read the newspaper. Yet our society still frequently and mistakenly views an individual with a disability as someone less than whole—as a "cripple."

A colleague of mine uses a wheelchair as a result of a spinal cord injury he suffered in an automobile accident. While that accident changed his life forever, he is far from the "invalid" that society frequently views him to be. He is a highly successful, well-compensated marketing executive, a nationally ranked wheelchair tennis athlete, a father of three children, and a former SWAT team police officer. Yet,

- Strangers in shopping malls have pitied him so much that they hand him money to buy himself clothing;

- Waitresses, assuming he cannot order his own meal, have asked his dinner companions to order for him;

- Parking-lot attendants have insisted on giving his car voucher to a passenger in his car, not to him; and

- Bank tellers have greeted him with "baby talk."

On a daily basis, he and 43 million other Americans with disabilities face pitiful, condescending attitudes that are extremely distasteful. Many of America's children are taught to ignore people with disabilities by parents who embarrassingly tell them it is "rude to look" at someone in a wheelchair or who is different in some way. As a result, they grow up with a level of discomfort in talking to, or even making eye contact with, someone who has a disability.

Fortunately, however, there is a world of change taking place around us. And it's changing for the better as our society learns to focus on the *abilities* of people—instead of their disabilities.

Note the shift in language. Twenty-five years ago, our society described this segment of the population as "cripples." When that term became too harsh, "invalid" was adopted. Eventually, "invalid" gave way to "handicapped," then "disabled," then "physically challenged." "People with disabilities" is now the generally accepted terminology.

Look also at the evolution of the wheelchair. Traditionally, wheelchairs were sixty-pound, institutional-looking pieces of medicinal equipment that screamed tragedy. Now, they have

been transformed into lightweight products loaded with style, vibrant colors, and exciting performance options that fit individual tastes and lifestyles.

As language and product design have evolved, so have our educational institutions, which are actively "mainstreaming" students with disabilities into schools with able-bodied children. The entertainment industry has produced successful films such as *Born on the Fourth of July* and television programs such as "Life Goes On" and "Reasonable Doubts," which would have been unheard of just five years ago. Even the airlines, thanks in part to the Air Carrier Access Act, will soon be more accessible.

Perhaps most important, President George Bush signed the Americans with Disabilities Act (ADA) on July 26, 1990. This landmark legislation will guarantee equal employment opportunity, provide access in public accommodations and transportation, and ban discrimination in state and local government programs for people with disabilities. As the guidelines take hold over the next several years, the ADA will heighten the awareness of the nation's able-bodied population that people with disabilities are no different from themselves.

The laws have been written. Now it's up to each one of us to change public opinion, to shift away from focusing on what people cannot do, to what they can do. Lynda Greer's collection of work was conceived and executed with this goal in mind. At Invacare Corporation, we are proud to be a sponsor of her efforts. After you have experienced this compilation of images and personal statements, we hope that you will work with us to change society's attitudes about people with disabilities.

A. Malachi Mixon III

Mr. Mixon is chairman, president, and chief executive officer of Ohio-based Invacare Corporation, the world's largest manufacturer of wheelchairs and other home medical equipment.

PREFACE

From the Photographer to the Reader

This project has been on my mind for a long time. In fact, when I was a little girl I noticed that people who didn't have disabilities sometimes behaved strangely toward those who did . . . like raising their voices when speaking to someone in a wheelchair, as if the ears were somehow in the legs. A neighbor always addressed the blind broom salesman that came to our street as if she were talking to a three year old. When I observed this behavior I felt a vague sense of embarrassment that I didn't quite understand. As an adult I understand it very well. I know how I feel when someone is condescending to me or treats me with less dignity than I deserve. Of course, I continued to notice this phenomenon and continued to be embarrassed by it.

A few years ago I read *Eclipse: A Nightmare** by Hugues de Montalembert, to whom this book is dedicated. Hugues was an artist, living in New York City, when two men broke into his apartment; one threw acid in his face, blinding him. His book is a fascinating account of how he maintained his strong visual sense and how he learned to live in a world that was greatly altered. In the course of his story he describes several instances when the insensitive, albeit well-meaning behavior of others causes him frustration, embarrassment. That was when I had the idea of making photographic portraits of people with disabilities and asking them to make personal statements. I hoped to publish the work as a book. My thought was that the portraits, combined with the personal statements, would help people understand that disability is a fact of life, not a defining characteristic.

During the three years (1989–1991) I have spent on this project I have learned a great deal from my subjects. One man told me that I "can't possibly know what it's like until (I've) been there." That is certainly true. I do know what I've come to believe about disability. One thing is that I don't think much of the term *disability*; oh, it's a lot better than some of the sappy euphemisms I've heard, but to me it has a negative connotation. (And I really hate to hear reference to *the* disabled.) When you think about it, what we have here is altered ability . . . the absence or loss of a particular function that requires compensation by other systems. It's wonderful that human beings can do this so well and fascinating to consider how it's done. I do believe that this process has the positive effect of giving these individuals an added dimension of human experience.

I've had a wonderful time getting to know the people in this book. I think you're going to like them, too.

*Hugues de Montalembert recently published a second book, *A Perte de Vue*, and is working on a screenplay of the first.

A WORLD OF CHANGE

ROBERT (Bobby) BROCK

I live in a house with three guys, and Julie, Carl, and Jennifer. Jennifer is Julie and Carl's little girl. I like the house, but I want my own apartment. Before I do that I need to prove that I can stay by myself.

Right now I'm working at J. B. C. Embroidery Apparel Plus. I put labels on boxes of uniforms. I go there three days a week. Someday I'd really like to be a bartender.

What I like to do is be with my friends . . . go to movies, have pizza. And I love to listen to music . . . all kinds of music.

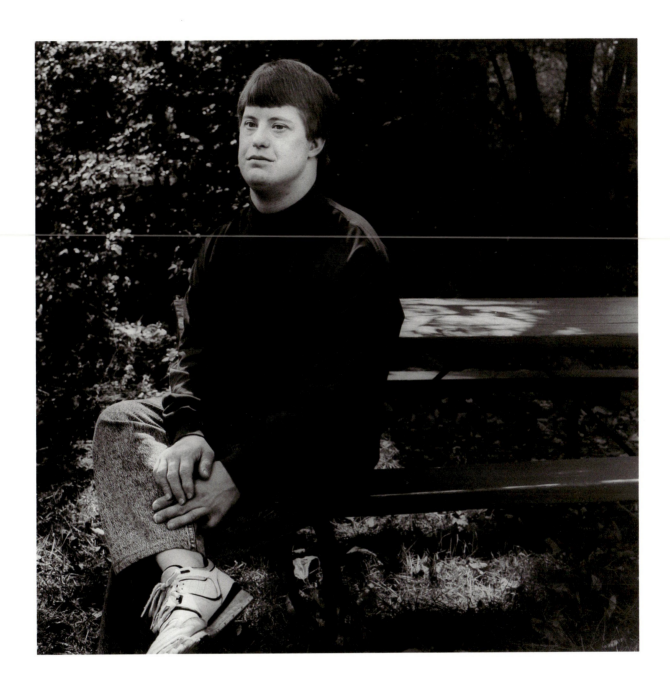

ROBERT (Bobby) BROCK was born with Down's syndrome. He is currently living with three other men, two resident managers (a married couple), and their child in suburban Atlanta, Georgia. Robert works three days a week and looks forward to the time when he can be on his own.

I grew up in a small south Georgia town; I went to college in a small south Georgia town. In school I always loved writing and performing. In college I learned that I was funny, and I loved getting laughs. Long before college I knew that to get what I wanted out of life, I'd have to leave south Georgia. In the summer of 1982 my wife and I and our baby boy headed for Atlanta, where I got a job as an editor for a TV listings company. Atlanta was the place for me, but not my wife. Before long she took our son and moved back to south Georgia. Suddenly I found myself completely on my own, and I realized this was a chance for me to see if I could make it as a writer and to see what I could really do as a performer. I quit my job to freelance and I started going to a comedy improv workshop, where I learned that you don't really have to know what you're doing. If you're good you can make it up as you go along and it works. That was kind of what I'd been doing all my life; I just didn't call it improvisation.

I worked for a while as a freelance writer. I guess I still hold the distinction of creating the only ad submitted by a broadcast company to be rejected by *TV Guide* as too risque.

Then I made another change. I went to work as a writer-producer with a radio commercial production house. Talk about improvisation! It was a big switch from writing copy to writing radio commercials. I learned a lot and had a LOT of fun with that job.

I still love comedy improv, too. For the past several years I've been working with a group of incredibly creative people. We're very demanding of each other and we like to push the edges. Comedy improv has limitless possibilities, and we're exploring every one of them.

It's kind of amazing how things are working out at this point in my life. I know I'll go on improvising, and lately I even know what I'm doing . . . some of the time.

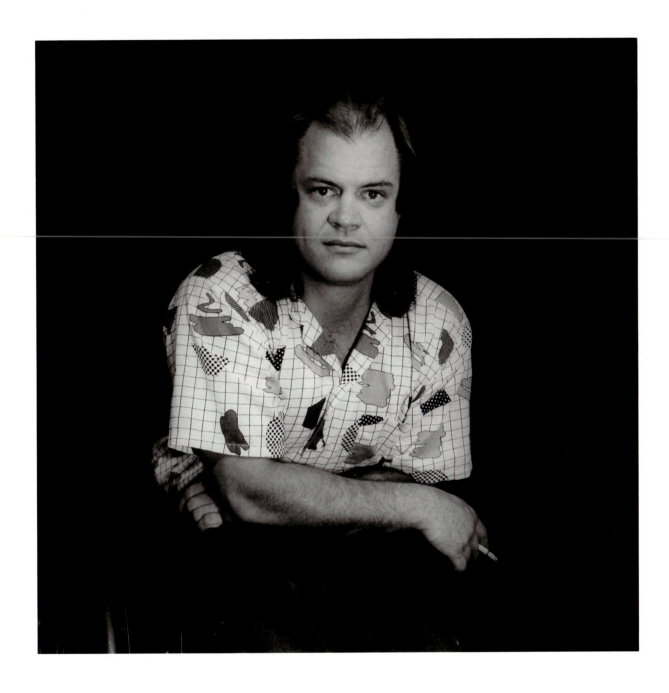

TOMMY FUTCH lives in Atlanta, Georgia, where he is a comedy writer and founding member of a comedy improvisation group that performs locally and regionally. He sustained a spinal cord injury in an automobile accident when he was seventeen years old.

I was raised in a small farming community in Maryland, part of a large family. Four of us were born with visual impairments. My twin brothers and a sister have somewhat better sight than mine. I can see shadows and light. Anyway, I attended the Maryland School for the Blind.

During the years at the school I developed my love of singing. Whenever I got the chance, I was singing. Some of us formed a group . . . we did some gospels and spirituals, doo-wop . . . mostly a cappella because we couldn't always find a piano. We sang on the porch of one of the cottages, on the sidewalks in town. Of course, the time came when we went our separate ways and the group broke up.

Not long before graduation I was told I wasn't college material. I knew that blind people had trouble finding good jobs and I didn't want to end up in a sheltered workshop, so when they suggested piano tuning I went for it. In 1966 I went to the Emil Fries Piano Hospital and Training Center in Vancouver, Washington. I spent some time in Baltimore and Fairfield, Connecticut, as a piano tuner, but I've been working in New York City since 1977.

My life in New York has been good. I took piano lessons for a while at the Lighthouse (a rehabilitation center for the blind) and learned a lot of music technique and theory . . . which helps my singing technique. I also sang in the choir there. In fact, I'm studying piano now at a school near me. After looking around for a church . . . and the music program was very important . . . I have joined the Abyssinian Baptist Church and sing in their choir. We do classical, gospel, and a little contemporary music. I transcribe the long pieces into braille, but must memorize the hymns.

One regret I do have is that I haven't gone to college. Oh, I did spend a year at City University. I learned the techniques of writing . . . research and organization . . . and liked that so much. But I ran out of money; and, because I have a job, I can't get any funds from the state for further education. It's very frustrating because I want to keep learning. To be knowledgeable, to keep the mind sharp, is so important. So I'll keep trying to find a way. Meanwhile I read a great deal . . . novels, the Bible, Christian literature. And I'm involved in a Bible study group and that does require research.

All in all, I have a very full and meaningful life.

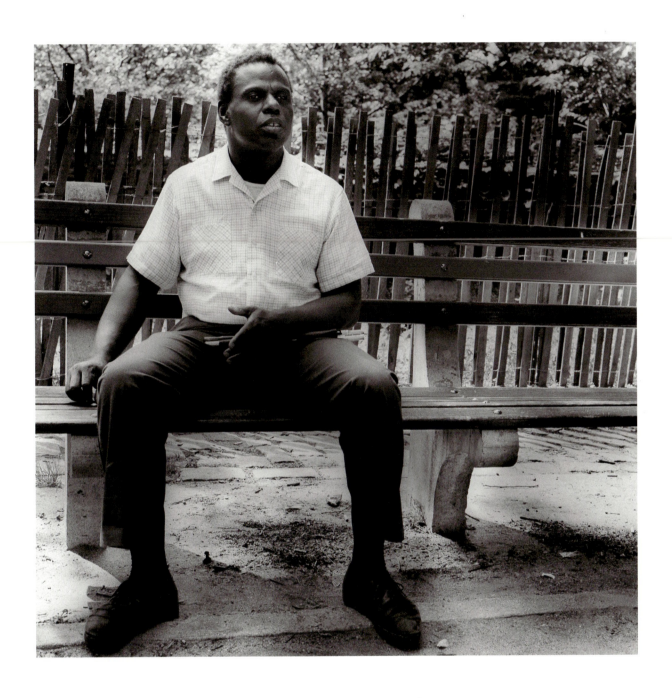

JAMES BARBER has been blind since birth. He lives in New York City, where he is a piano tuner. He is a member of the choir at the Abyssinian Baptist Church.

I guess I was one of the pioneer children in special education in Atlanta. In 1953, when I was four, the first special-education class for black children opened up. It was funded by Easter Seals and sixteen of us were selected by doctors at a clinic in Atlanta. When my mother learned of the program she pushed hard to see that I got in; she wanted her baby to go to school. When I went to the elementary program, the teacher from preschool went with us. Mrs. Muscia White was the only black teacher in the city with a background in special ed. More important than her background, though, was her belief that her "babies" deserved the best. She exposed us to a lot of things other kids didn't get . . . all kinds of field trips . . . to a farm . . . the symphony. After all this time she still keeps up with her "babies." This was a very important time in my life; it was during this period that Kate was formed.

In the sixth and seventh grades I was mainstreamed on a partial basis. It was great! Those kids treated me like one of the gang. These same kids were my classmates at Booker T. Washington High School, the first black high school built in Atlanta. So I had a support system already. The only real problems I had were architectural barriers.

By the time I got to college *those* barriers weren't a problem. I wanted to go into marketing. I've always had strong writing skills and wanted to use them in the area of marketing. One of my professors told me that he didn't think I'd make it in marketing because the business world wasn't ready for a severely disabled person who made strange involuntary movements and talked what I call the "C.P. dialect." And he was right. For every interview I had I got a ridiculous reason I couldn't have the job. None of them had anything to do with my professional ability. I was shocked and angry. Up until college I believed that if a person was smart enough and worked hard enough, disability didn't make any difference.

So I decided I was going to save the world . . . at least for kids with disabilities that would come along later. The first thing I did was serve on the accommodations committee for Federal Section 504 funding qualifications. Since then I have served on a lot of committees, councils, etc., to secure a better life for people with disabilities. The most frustrating thing is that it should be so simple. The basic level of accessibility to life . . . jobs, transportation . . . housing . . . should be there for all of us without such a struggle. But that's not the way it is. And *until* that's the way it is, Kate Gainer will be out there, *working!*

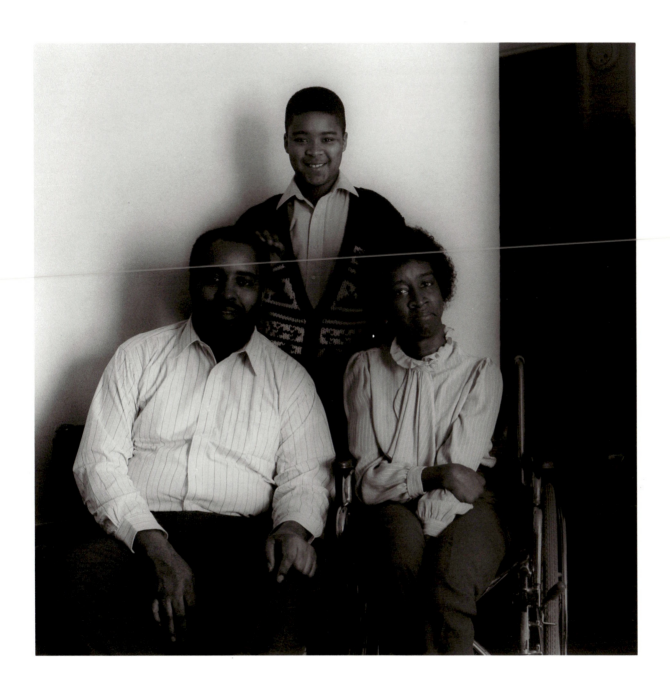

KATE GAINER, pictured with her husband, Willie Smith, and their son, Michael, was born with cerebral palsy. Kate is an active advocate for people with disabilities. She also works for the Atlanta Center for Independent Living.

The job I have now is the job I've wanted since I was eighteen years old. Here's how it happened. My vision was always bad, and when I was six I discovered that I had no sight at all in my left eye. Doctors never could tell us why, and they prescribed glasses for the right one. In high school the glasses stopped working, and the summer I was eighteen . . . 1975 . . . I went to the Roosevelt Rehabilitation Institute in Warm Springs, Georgia, for training. The staff there saw how fast my vision was going and recommended that I stay on, so three months grew into a year. I was so impressed with the way the counselors there could motivate me . . . amazed that they could see potential in an eighteen-year-old kid . . . and I began to think I'd like to do that kind of work. I was very influenced by a man named Bobby Chisholm, who worked with me every day, helping me relearn the skills I needed to get along in the sighted world. He was totally blind himself, had a master's degree in counseling, and was excellent at what he did . . . and I knew that was what I wanted to do.

The road from Warm Springs didn't lead me directly back here. It wandered through college and a bad year when I couldn't find a job anywhere . . . to Atlanta for more training in braille. Along the way I met and married a lovely young woman named Kathy.

Six months after we were married, the call came from Warm Springs. In 1984 we moved down and I began working as a braille instructor at the institute. After that, good things started happening fast. On a cold night in January of 1986, our son, Cameron, was born. I was in the delivery room. What a moment that was for Kathy and me! In 1987 I was moved to counseling to work with neurologically impaired clients. (My wife also works with people who are neurologically impaired.) In 1989 I got my master's in counseling (after working for two hard years). I really like working with blind and visually impaired clients.

Ironically Cameron helped solve the mystery of my sight. Recently he showed signs of a visual problem and we took him to a doctor in Atlanta, who seemed as interested in me as in Cameron. His conclusion was that Cameron is suffering from a condition that is hereditary and is almost certainly what I had. The good news is that Cameron's sight can be saved.

While I sure can't say I'm glad I lost my vision, I can appreciate the fact that its loss led me to a rewarding career and gave me certain insight that is invaluable to my work. I have learned and, I think, can help others understand that man does not see with his eyes alone.

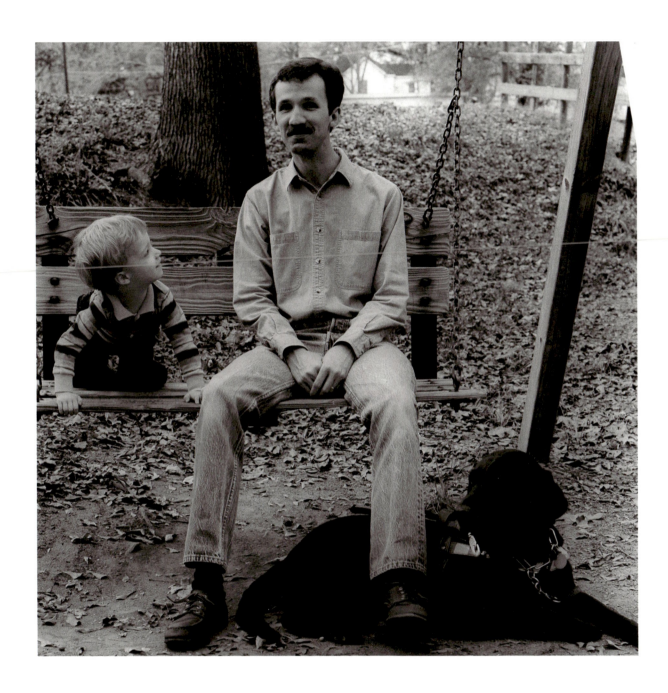

DANNEY YATES was born with a degenerative ophthalmic condition that caused him to be totally blind at the age of twenty-one. He lives in Warm Springs, Georgia, with his wife, Kathy, and their son, Cameron (pictured). Danney is a rehabilitation counselor at the Roosevelt Rehabilitation Institute, working with blind and visually impaired people.

CHRISTOPHER — I'm in the first grade. I like school; what I like best about school is learning things and exercise. I like exercise a lot . . . doing sit-ups and push-ups. At school I have three teachers . . . one who works with the students, one aide that helps Eric and me, and one aide that helps the teacher.

When I'm not in school, I play with my toys. Mostly I play inside my bedroom. I have a toy jeep that I ride around outside. I like game shows on TV and watching horse races.

I just got a great new wheelchair that folds and is light. We take it places.

My aunt gave me a great book that tells all about me . . . like who I am inside. Its name is *I'm Not So Different*.

ERIC — My name is Eric Omar Harris. I'm seven years old. My birthday is May 24. I go to Cartersville Elementary. I'm in the first grade. My friend . . . sometimes I call him Chris, sometimes Christopher . . . is in all my classes, but sometimes he's not in P.E. because he goes to therapy. So do I sometimes. We also ride the school bus together. Mostly at school I like P.E. and math and drawing. Sometimes I sketch a little but what I draw comes out a little weird.

At home I usually play Batman. Sometimes on my computer I do math and play word games. I like TV a lot. "Batman" in the day, "Cosby Show" at night.

I came to live with Mommy when I was a baby. When I was five she adopted me.

Me and Christopher plan to be superheroes when we grow up . . . like Batman and Dragon. (I made up Dragon.)

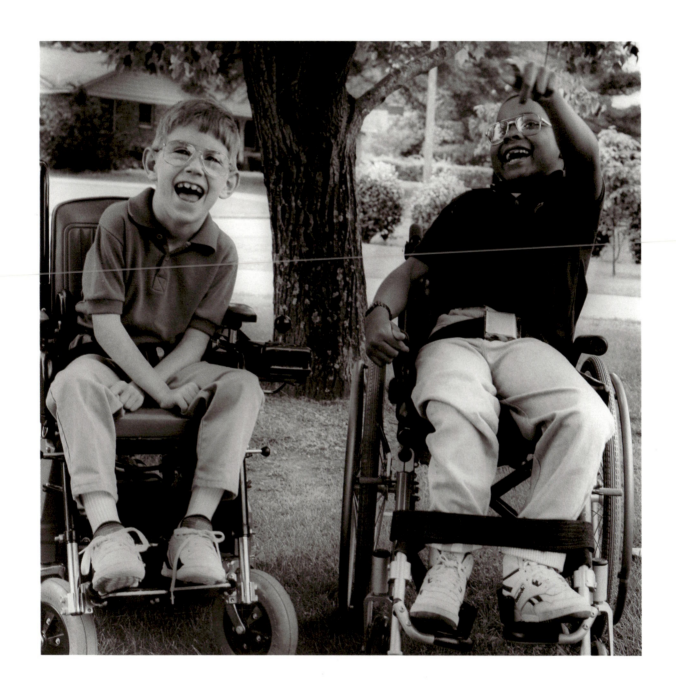

CHRISTOPHER GODWIN (left) and **ERIC HARRIS** were born with cerebral palsy. They are good friends and attend elementary school in Cartersville, Georgia. Christopher lives with his parents and younger sister. Eric has lived in foster care with Louise Harris since infancy. Mrs. Harris legally adopted Eric in 1988.

Right out of high school I worked a factory job, making electrical boxes for homes. I put screws in with an air-compressed drill. A boring job that tore my hands up. Using crutches made it worse.

I'd been interested in radio since high school. So in 1974 I made a career change. That was sixteen years ago. I kept my day job while I trained at a station three nights a week. I started working the midnight to 6:00 a.m. shift, then moved to the 10:00 p.m. to 2:00 a.m. shift. That's an experience everybody who goes into radio should have!

In January of 1989 I became program director at WLYU-FM . . . had about six guys under me. I like that alright; it's a lot of administrative stuff. The deejay part is the fun part of radio for me. You can really let your hair down. Now we've gone to satellite format, and it cuts down on the personnel and the administrative headaches. What I like about this is it's a different job every day. One day you may have everybody in the county calling with all kinds of problems. Next day, it can be quiet for five hours. We do get all kind of calls . . . girlfriend problems, boyfriends . . . What they don't know is that you're having the same problems in your life. Too bad you can't give yourself advice!

This isn't a perfect job . . . long hours. I usually put in a ten or eleven hour day. From late August to November we cover local high school football, every Friday night until late. Kind of cuts into your social life. But I've been doing it so long, it's kind of like a second skin. And I really like the contact with the listeners . . . playing the music. Yeah, I guess this is what I'll be doing for a long time.

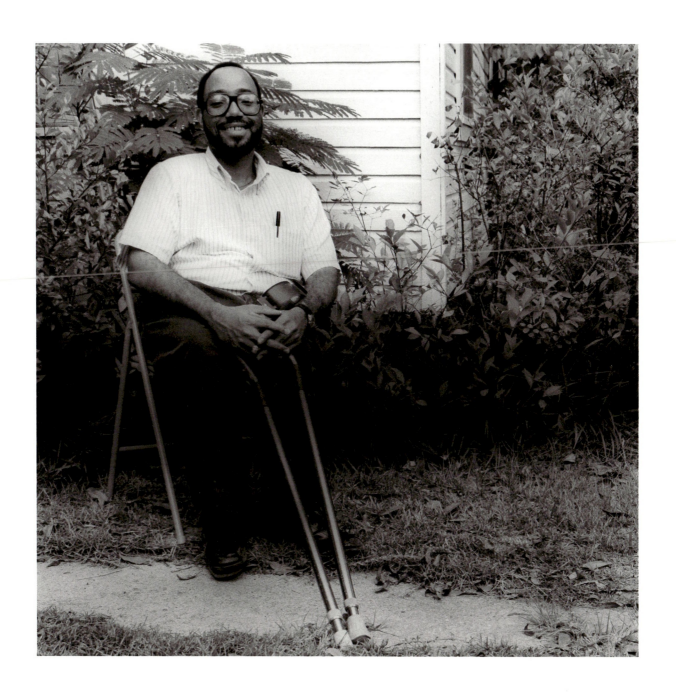

EARL AVERITT (Earl the Pearl to his listeners) lives in Vidalia, Georgia, where he is a disc jockey and program director for a local radio station. Earl was born with spina bifida.

It was November 1985. I was on my way to a UCLA basketball practice . . . I was working with the team . . . when the engine on my motorcycle seized up on me, doing a curve at about 40 MPH; and I slammed into a utility pole. As a chiropractor I do know about the spine, so I knew right away what the score was.

Basketball and fitness have been part of my life since I can remember, so well-meaning people suggested that I go for wheelchair basketball. No way would I settle for less with a sport I excelled in on my feet. So in the hospital I set my mind on the triathlon. I've always been a competitor, and the accident didn't kill that spirit. The triathlon is a grueling event . . . just what I wanted. Two months after the accident I was training fifteen to twenty hours a week. I'm most competitive in the swimming and running events, weaker in the cycling division. For swimming I wear a wet suit and webbed gloves to give me power, and I do the backstroke . . . breathing's easier. For the run I use a lightweight chair and I use a hand-powered bike designed and built by my friend Bruce Eikelberger. We're working to develop a better bike.

I love the challenge of racing. But it isn't just for me that I do this. I intend to change the image most adults have of people in chairs. And I'm doing it in an effort to raise bucks as well as consciousness. Attitude-wise I want to teach people that being in a chair isn't the most disabling thing; it's the attitudes of others. Sometimes it's very difficult for athletes to participate in certain events. I've had my share of rejection because I'm in a chair and a pain in the butt to work around. This segregating athletic events along able-bodied/disabled lines has to stop. And I'm also racing to get sponsors to help raise money for research and technical advances. I believe I'll be out of this chair someday and that kids . . . anyone with a spinal cord injury . . . deserve the chance of complete recovery.

But as long as I'm in this chair I'm going to prove to others that people in chairs are really no different from them. A lot of people don't feel comfortable with wheelchairs . . . and that's got to change. Believe me. It will be better for everybody.

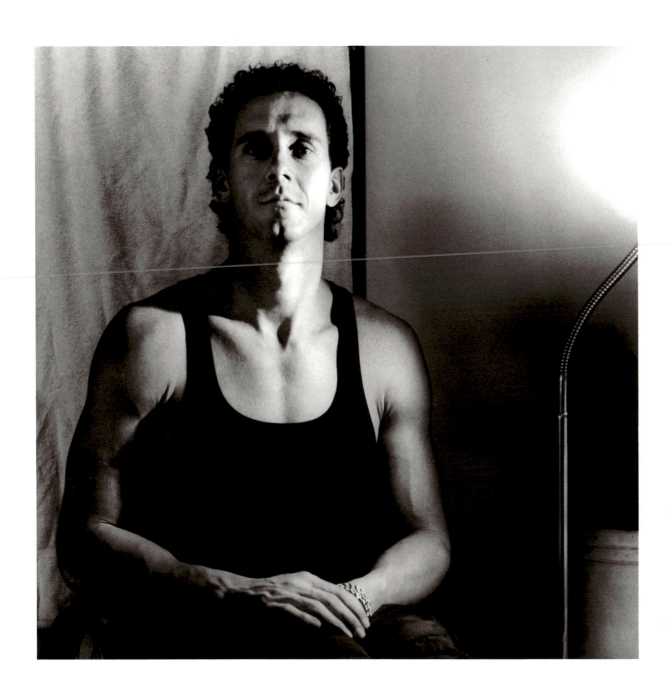

JON FRANKS is a chiropractor and owner/director of a physical fitness center in Venice Beach, California. He sustained a spinal cord injury as a result of a motorcycle accident in 1982. Following the accident he began training as a triathlete. He has participated in triathlons in the United States, Europe, China, and the Virgin Islands.

I was born into a family with the resources to help me meet all my needs and more. So I feel an obligation . . . no, not an obligation, it's just part of me . . . to help people reach for the stars. All of us have something to deal with, and I know that we can go beyond simply dealing with something to meet our individual potential. I work with a program, the Challenged Child, an early-intervention program for children from birth to age five with various developmental disabilities. The primary objective is to enable these kids to be "mainstreamed," not only in school but in all aspects of their lives. If you begin early enough, children can achieve a lot. They learn to think "I can" more than "I can't."

Sometimes my duties involve talking to parents, helping them maintain positive attitudes about their children's situations. They, too, must think "can" more than "can't"; and I think my example, as much as my words, shows them not only what their children can do but what an important role they play in providing a supportive environment for their very special children.

This work is a very satisfying part of my life.

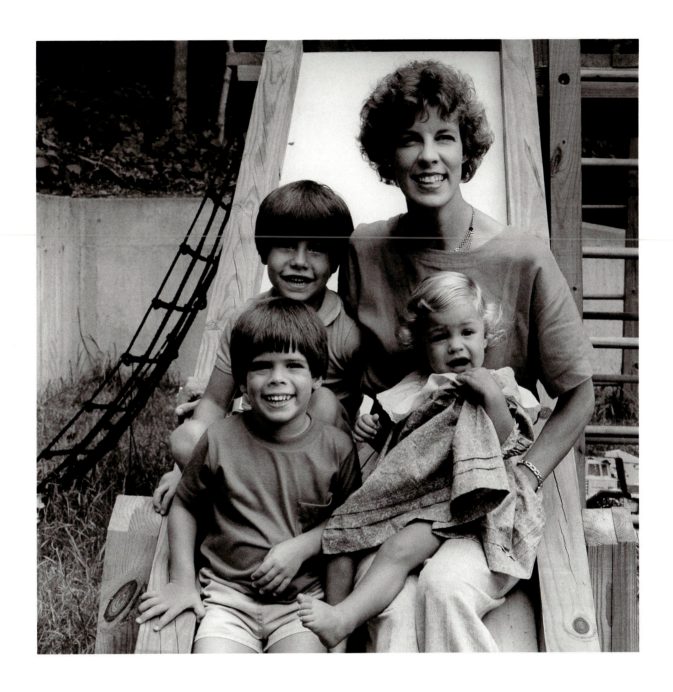

EVE WILHEIT KACOS is an active community service volunteer in Gainesville, Georgia, where she lives with her husband, Mark, and children, Will, Ben, and Julia (pictured). Eve was born with cerebral palsy.

I can give you pages of biographical material, but I'm more interested in talking about my job as White House press secretary to President Reagan. For me that was THE job; I trained for it all my life, in fact. I spent a lot of time in previous jobs hanging around the Press Office, talking to the press secretary, thinking that someday I'd like a shot at what he was doing. I thought it was the best job in the free world . . . still do . . . and one of the most challenging.

The toughest part had to be the daily briefings. Any briefing I could walk away from was a good one. If the members of the press were doing a good job then they were making me work extremely hard. What I had to do was please my boss and still be up front with the press. The information business can be tricky . . . on both sides. Respect and trust become very important. If the press doesn't like you, they can do you in. I always tried to give them reason to respect me and to believe they could trust me. And God knows I respected them!

Another thing that I loved would drive saner men crazy. Every morning I was in my office at 5:15 a.m. I'd have a fire, even in the summer, a pot of tea, and my pipe. It was a brief moment of calm before the pandemonium of the day began. And the day could go on and on . . . often until 3:30 a.m. I called my wife the news widow. Any time I spent with our son had to be stolen in the early morning hours or just before he went to bed. That lack of family time was tough. Still, I do miss that job. Those were great times!

Then a funny thing happened on the way to the Hilton. Now that may sound like black humor to you, but humor . . . whatever color . . . helped us all through what came next. Those interested in detail about the several years following March 30, 1981, can read my biography, *Thumbs Up*, by Mollie Dickenson. No one . . . least of all the Bear . . . wants to talk about pain and suffering. What happened to me is history; it's in the past. And now my show is on the road again.

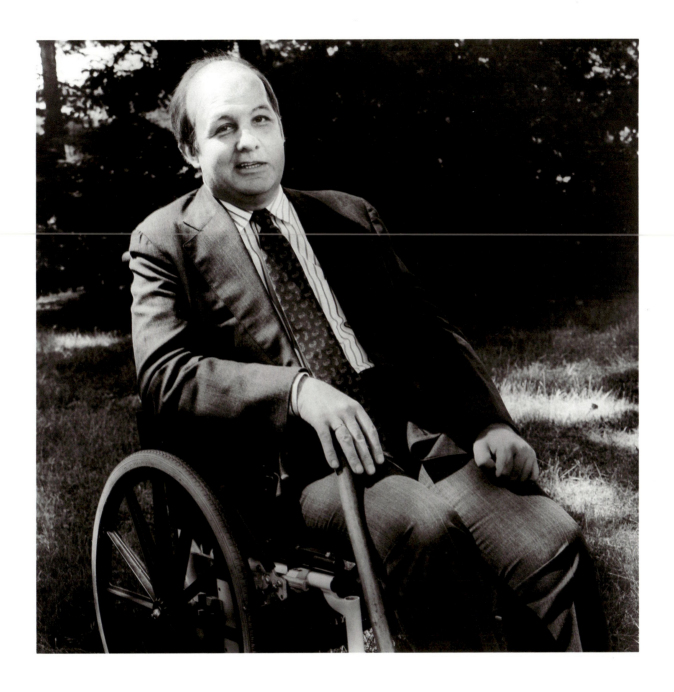

JAMES BRADY and his family live in Arlington, Virginia. He works in Washington, D.C., as the vice chairman of the National Organization on Disabilities, and he works closely with Mrs. Brady in her campaign for gun control in America. In 1981, while serving as White House press secretary, he was shot in an assassination attempt on President Ronald Reagan and sustained a serious head injury.

WILL — I was born in Augusta, Georgia. I have a brother who is named Robby Smith. My father is a doctor and my mother deals with art. When I was three years old, the whole family moved to Gainesville. Now I go to a school called Gainesville Middle School. I have some friends named Chip and Justin, and a bunch of others that I cannot remember their names.

I am an editor and a movie reviewer for the Gainesville Middle School's newspaper, *The Mirror*. I hate *The Mirror* but I always wanted to be an editor and a movie reviewer so I got no choice. I always get a feeling like I am a special guest of the newspaper and I try to take a break from it whenever possible.

I have a lot of hobbies. I am not sure exactly how many, but I got comic books, rockets, stamps, books, movie reviews, articles, posters, and role-playing games.

I have told you not all, but some parts of my life.

ROBBY — Hey! Well, my name is Robby Smith and I have a hearing loss and eyesight problem. I'm heavily addicted to "Cheers," "Night Court," and "L.A. Law." I love reading books, and usually stake out the local bookstore when I hear that a good book has been published.

I enjoy living life to the fullest and relaxing. I like to go to the beach, the city, and the mountains. Next year (1989) I'm going to be a freshman at high school. My favorite movies are the Indiana Jones trilogy, *Who Framed Roger Rabbit*, *Midnight Run*, and *Mr. North*.

My hearing/sight losses never bother me, and I really don't make a major deal out of it.

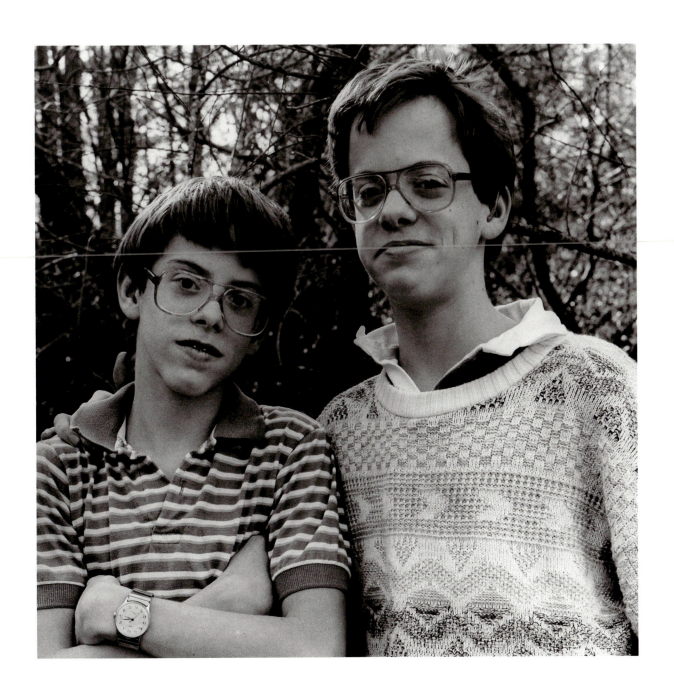

Fraternal twins **WILL** and **ROBBY SMITH** are high school students in Gainesville, Georgia. Born prematurely, they sustained severe hearing losses during neonatal care.

My eyesight was never any good, but nobody really knew for a long time. My mother worked in domestic and restaurant service; my father was a heavy equipment operator. They stayed busy, working and raising ten kids. Of course when I started to school, I had to deal with it. I developed certain "tricks of the trade" to compensate and conceal my poor vision. They worked pretty well most of the time. I went through school as a sighted person and graduated a quarter early. But by the time I was seventeen I was legally blind in my left eye and had no vision in my right.

Between 1973 and 1978 my sight deteriorated rapidly, but after working for three years I was finally able to start college . . . while still working . . . in 1976.

In 1978 I began to come to grips with the fact of my blindness. I quit working and took time off from school to do rehabilitation training. During this time I came to the realization that I'm me, blind or not blind, and that was fine. After the time in rehab training I had the confidence to go back to college full time.

Since I was young I've wanted to be in a helping profession, to do something socially responsible. I grew up hearing the cries of the sixties and seventies, aware of the need to create social change. So while in college I decided to become a criminal lawyer . . . to help those accused of crimes. I'm not talking about corporate types . . . rich people who hire big names for big money. I mean the little guy . . . usually not much money, no real understanding of the system . . . who is in trouble and scared. For five years after law school I worked on the civil side of poverty law practice for the Atlanta, Georgia, Legal Aid Society and now I'm practicing on my own. I just opened my office in early 1990. It's a big step; there are no guarantees it will work out. But it's a step I had to take.

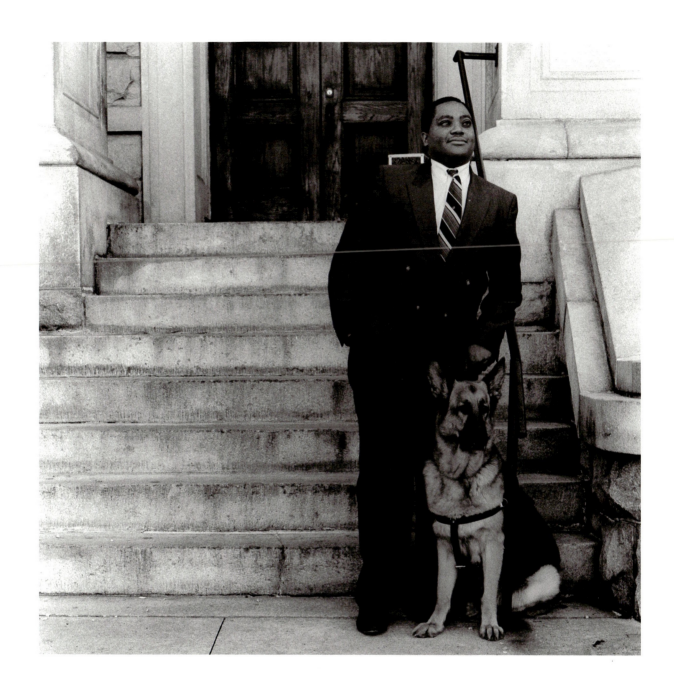

C. ANTHONY CUNNINGHAM lives in Decatur, Georgia, where he is an attorney. He was born with a degenerative ophthalmic disorder.

STEPHANIE — Social activism probably was in my future all along. I went to a Quaker grammar school. Their philosophy of social justice and personal responsibility in that regard had a real impact. And then I grew up during the civil rights movement.

BOB — I definitely came along in the activist tradition. My grandparents on my mother's side were Russian immigrants and real activists . . . union, peace, civil rights. My parents were political activists and active in the union.

STEPHANIE — My career as an activist began my freshman year at Harvard. As a disabled student I was in a real minority. There was a great need for changes in attitude and accessibility on campus, so I helped organize a group . . . and we did, in fact, make some important changes.

BOB — Like Stephanie, my serious activist efforts started after I was injured. I went back for a master's in special ed and worked as coordinator of handicapped students at the University of Houston. Then I moved to Austin. I was a Vista volunteer and working in the Coalition of Texans with Disabilities.

STEPHANIE — Meanwhile I had moved to Austin, but we met on various projects while I was still in El Paso. It was a sort of long distance thing for a while . . . until I came to Austin. We were married in 1986.

BOB — Stephanie got me involved in ADAPT (American Disabled for Attendant Programs Today) in 1984. Then we got a grant to start ADAPT Texas and do a newsletter, which has evolved into the national newsletter *Incitement.*

STEPHANIE — We still work with the coalition, but our focus is ADAPT, which is issue specific. We are a community of people dedicated to disability rights . . . willing to take any actions to win these rights . . . to change the image of disabled people as passive and helpless. We are willing even to go to jail . . . and have.

BOB — This is no nine-to-five job!

STEPHANIE — And sometimes the line between work and nonwork blurs. Our lives are so directly involved with our work.

BOB — Self-interest is part of it. If the world isn't accessible, we can't live in it.

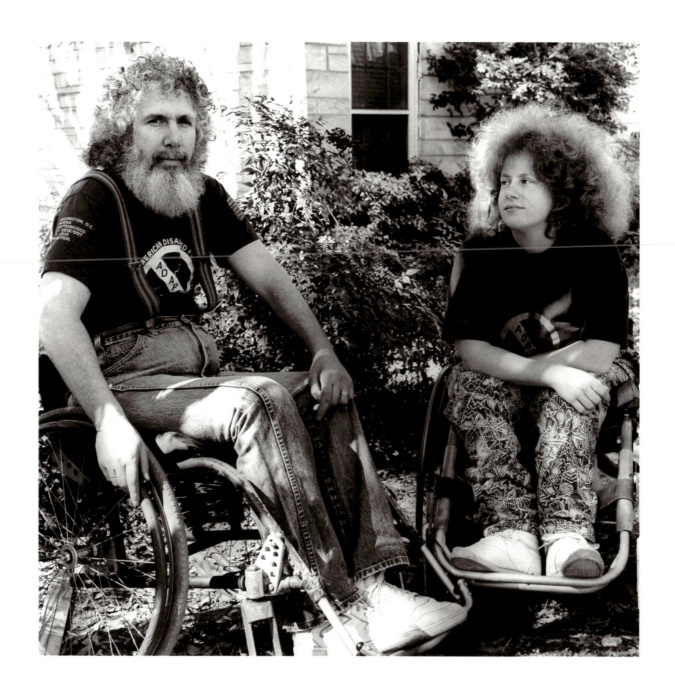

BOB KAFKA and **STEPHANIE THOMAS** live in Austin, Texas, where they founded
and run ADAPT (American Disabled for Attendant Programs Today) in Texas and publish the
national newsletter *Incitement.* Bob sustained a spinal cord injury in an automobile accident;
Stephanie, in a tractor accident.

My mother is Japanese; my father is "Hapa-Hauole," which is half-Caucasian in Hawaiian. He's half-Japanese and half-German. I grew up on Oahu. Like most kids, I got interested in cars when I was in high school. When I was eighteen I joined the Army Reserve because they would pay for my education and I wanted to train as a mechanic.

Then, in 1984, I was in a car accident. Because of the accident I had to change my direction. I honestly didn't go through any depression about being in a chair. Pretty soon after I was hurt, I got into all kinds of sports . . . basketball, ping-pong, racing. In 1985 I broke the Hawaiian record in the Honolulu Wheelchair Marathon.

Also in 1985, I was starting with tennis. Before long I was obsessed with the sport. In fact, I won my first tournament before I won the marathon. After that I concentrated on tennis. Since then tennis has pretty much been my life. One thing I like is that the sport allows me to be competitive with able-bodied players . . . unlike most wheelchair sports. With the exception of a double-bounce rule for players in chairs, it's the same rules, the same skills.

I don't have any definite plans for the future, but I think I'd like to focus in some way on tennis. One thing I've enjoyed a lot . . . I started about a year and a half ago . . . is introducing wheelchair tennis to kids in rehab centers, hospitals, schools. It isn't just kids who are hurt . . . able-bodied kids get a kick out of tennis, too. I love working with kids. They're honest; they either like you or they don't. And they let you know. They're so eager to learn and they aren't afraid to ask questions or try new things. I don't know; working with kids may be in my future.

Right now, though, I'm just focused on tennis. My life is spent training and playing, training and playing. And right now, that's a great life!

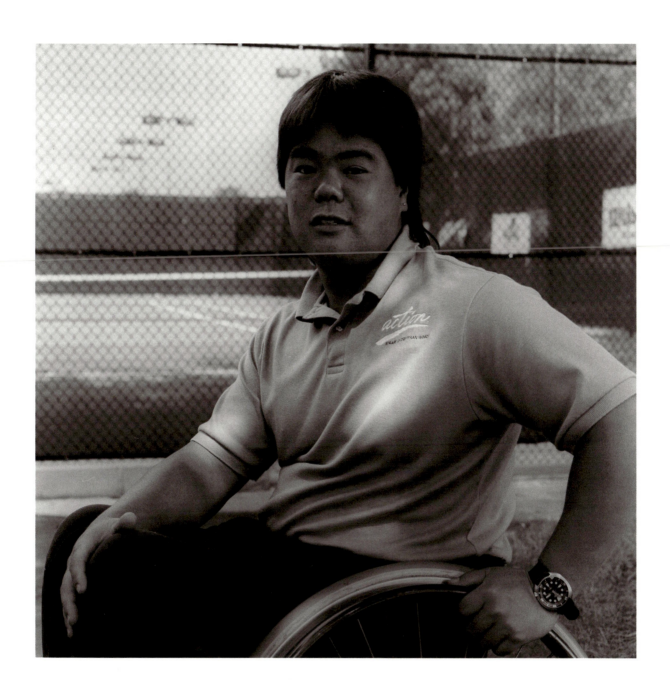

JOHN GREER, a world-class wheelchair tennis player, lives in Kaneohe, Hawaii. He also does volunteer work with children. John sustained a spinal cord injury in a car accident in 1984.

I didn't have any direction. I guess you'd say, until after I was hurt . . . car accident. My family moved around a bit. We went to Georgia when I was thirteen. I got in with a wild bunch . . . did a lot of the typical seventies stuff and quit school at sixteen. When I was seventeen I started work as a welder. After five years of welding . . . and one real close call on the job . . . I went to work in my dad's restaurant.

The accident happened when I was twenty-five. I fell asleep at the wheel one night. For a year and a half I didn't do a lot. Right after the accident I read about wheelchair tennis, so I tried that for a while. Then I met some people from the track team at Shepherd Spinal Center. I loved racing . . . the competition, being around other racers, and traveling around to races.

By 1987 I had moved to Atlanta and I went in business with another guy . . . durable medical equipment, selling and maintaining chairs, beds, environmental control units, modifying electric chairs. So serious racing ended for me. After a couple of years I sold my partner my end of the business.

Then I got into serious water-ski competition. I had been doing it for a while. Before I moved to Atlanta, I'd come up for races and met a guy named Bill Furbish, who taught me to water-ski. A month after I started, I was competing in the U.S. Nationals. I've been to California, where I was introduced to the air chair ski. It's an able-bodied ski, but we modified it for my use . . . great ski for rough water. I've still got to work on the design for competition. I compete in three events: slalom, trick, and jump. Last year I won the national jump title, so I go to the world competition in 1991.

I'm also involved with Adaptive Aquatics, a nonprofit teaching organization. We mostly work with rehab centers, so most of the people are adults who have had traumatic injuries. I'd like to do an all-kids group . . . work through children's hospitals.

My motivational aspect for almost anything I do is contact with people. I love making friends. Money isn't important; doing what I enjoy is. I want to find a way to combine skiing and earning a living. And I have some ideas about wheelchair accessories . . . like ways to make it easy to get out in the woods to hunt. I hunt, modified a particular chair for the purpose. I get ideas from other people about what they need, and I'm thinking all the time. Someday I just may invent something spectacular!

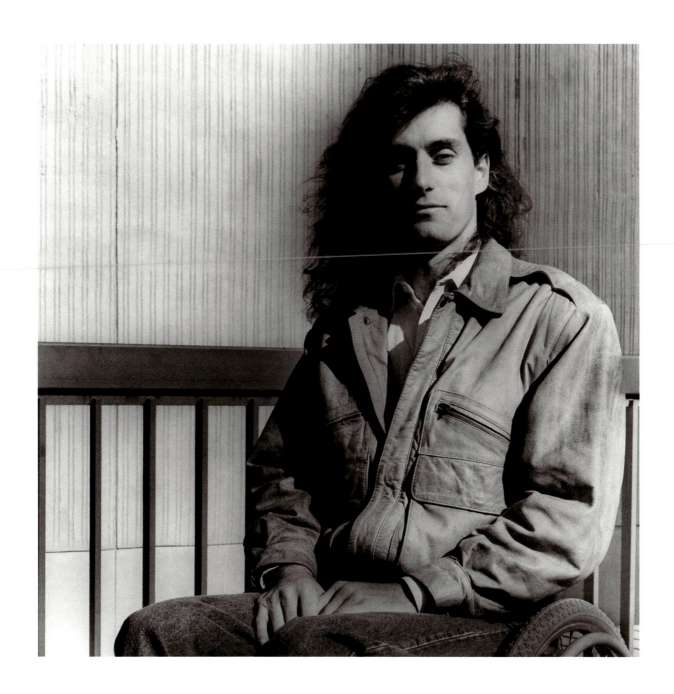

CRAIG WOMACK divides his time between Florida and Georgia. An accomplished water-skier and instructor, he has taught most recently at the Water Ski School for the Physically Challenged in Winter Haven, Florida. Craig sustained a spinal cord injury in an automobile accident when he was twenty-five.

JUSTIN DART

I was involved in the civil rights movement in the sixties and seventies, but for years now I have been involved in an even farther reaching civil rights movement . . . for the rights of people with disabilities. Disability crosses all lines . . . ethnic, socioeconomic, political, gender, age. In fact, if we live long enough, it will affect all of us to some degree.

Like that other civil rights movement, our efforts resulted in a legislative milestone, the Americans with Disabilities Act. Signed on July 26, 1990, this bill is designed to guarantee all Americans with disabilities equal opportunity and total public access. As I watched George Bush sign the bill on that bright summer day I did not feel the exultation of victory. As the thousands of people in the Rose Garden applauded his stirring speech, as he handed me one of the pens used to sign that momentous piece of legislation, I could only think of the enormous challenge that lay ahead . . . the challenge of implementation. This day, I knew, was only the beginning. Full implementation will come only when Americans whose lives have not been touched by disability learn to put it in perspective, to truly understand that those of us who have disabilities are individuals whose lives and expectations regarding quality of life differ very little from their own.

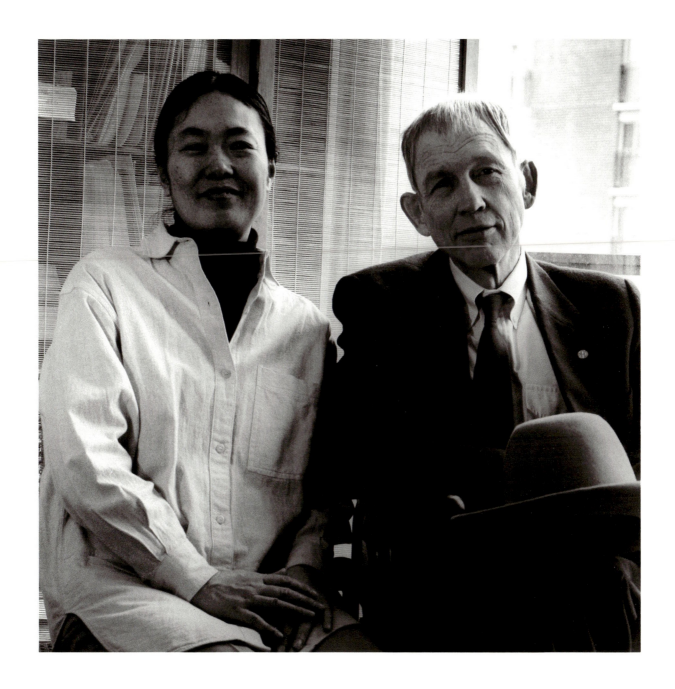

JUSTIN DART served as chairman of the President's Committee on Employment of People with Disabilities. He and his wife, Yoshiko, live in Washington, D.C. Mr. Dart had polio when he was eighteen years old.

Since I finished graduate school in the early sixties, I've worked as an artist, teacher, and political activist. While I was a member of the Clay Art Center in Port Chester, New York, I was invited to spend a year running an art workshop for children at the CORE Community Center in Sumter, South Carolina. I had been active in CORE since graduate school in Cleveland, where I had taught art at an inner-city YM/YWCA.

In 1967 I moved to Brooklyn, set up a studio, and taught ceramics at the Brooklyn Museum Art School for eleven years. After that I worked at Essex County College in Newark, New Jersey, teaching ceramics to senior citizens in housing projects, nursing homes, and places like the ILGWU Hall, which was one of my favorites because of the great lively mix of women who had immigrated either from the South or from Europe.

In the early eighties I was named to the NEA's National Crafts Task Force, which enabled me to travel and meet craft artists from all over the country, making many valuable connections.

Next I worked for Disabled Museum Visitors' Services at the Metropolitan Museum of Art in New York. One of my projects was an intergenerational clay workshop at a nursing home in Brooklyn. Kids from a rehab program at a nearby hospital were paired in the class with residents. The climax of the project was a trip to the Met to look at ceramics.

Another part of my work at the Met was to represent the museum at the United Nations' Conference on the International Year of Disabled People. I met many activists in the field of disability rights. I was able to apply my experience in the civil rights movement to working for similar rights for myself and other disabled people.

I am not really involved with institutional disability organizations because they are rarely run or controlled by disabled people themselves. At the present time I am on the boards of Resources for Artists with Disabilities and the NYC Chapter of the Women's Caucus for Art. Resources' founder is a professional artist who has a disability. One of Resources' goals is to get disabled artists into the mainstream art world by providing services such as transportation for art work and exhibition information.

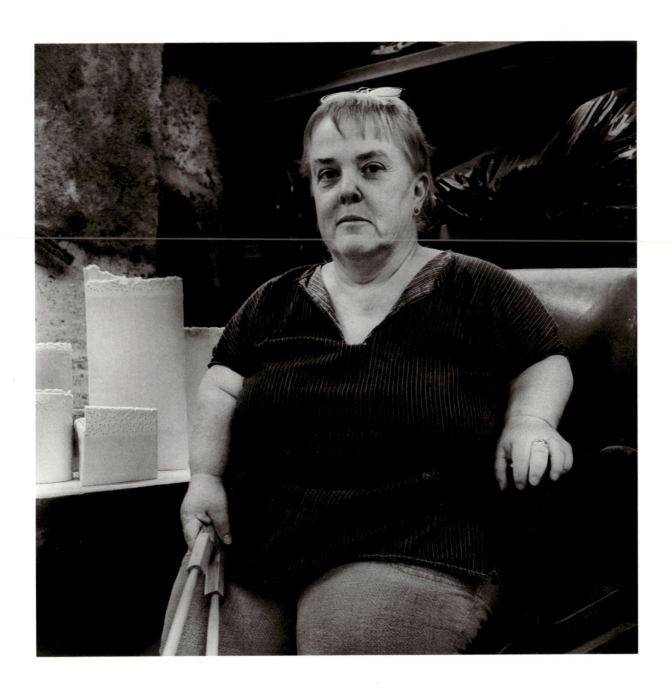

JACQUELINE (Jacki) CLIPSHAM is an artist who works in clay, as well as a writer, social critic, and disabilities activist. Her home and studio are in Califon, New Jersey. Jacki was born with achondroplasia, a congenital disorder of bone structure that results in deformities and dwarfing of the skeleton.

JAMES BENJAMIN (Benny) BAUMGARDT

The most important thing is working for God. I believe in my own heart that if we don't do our best for God there isn't any way we can make it by ourselves. And that is one reason I try to live for God. God has told me to preach and I'm going to try my best to do it. It may take me a while before I start preaching, but I know one day I will.

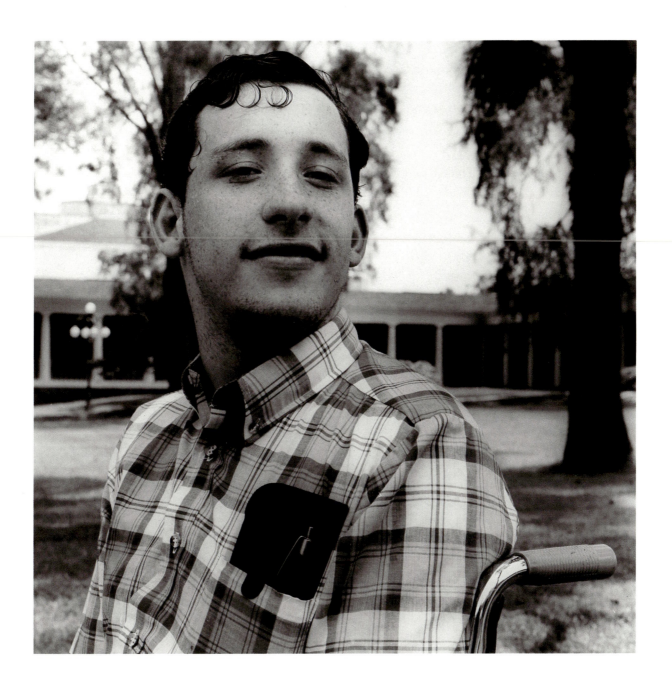

JAMES BENJAMIN (Benny) BAUMGARDT lives in Surrency, Georgia, with his parents and sister. He is an ordained minister in the Church of God and enjoys singing contemporary religious songs. Benny was born with cerebral palsy.

I was born in New Zealand. That's why I have this accent. My school is Montgomery Elementary School. I like math best. Katherine Boyd is my best friend at school and she sits by me on the bus. I have a sister; her name is Kim.

Susie is our dog and we have Jasper, the cat. She plays with my hair and my socks. Smokey is our other cat. She's kind of lazy and doesn't like Susie.

I like to jump on my trampoline and play on my swing set. I also like to roller skate in the kitchen; it's not as dangerous as on the street.

Gymnastics is great fun! I do the floor routine, the beam routine, and the vault. This year I was in the Special Olympics. I got two red ribbons.

For a long time I've been taking riding lessons. I go once a week. The pony in the picture is Misty. She's a stubborn pony, but I like her. Captain is a horse I ride, and also Shadow. Riding is great!

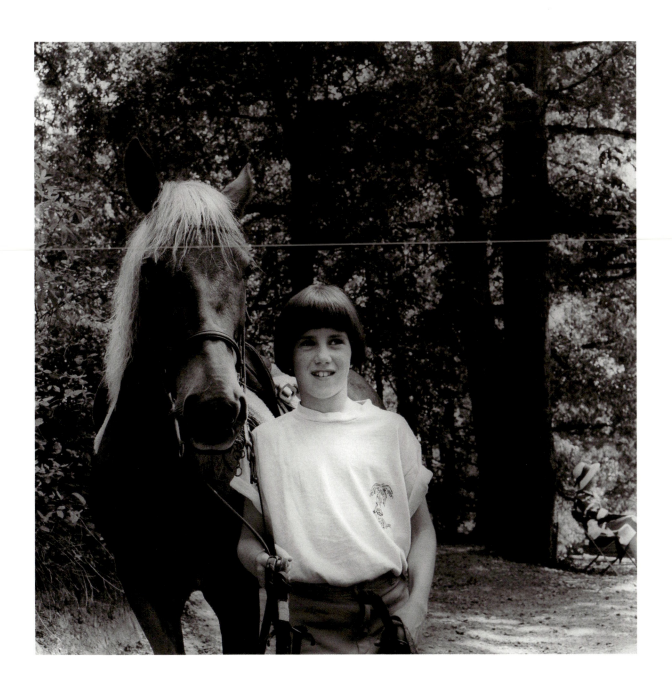

ANNA MORINE lives with her parents and older sister, Kim, in Dunwoody, Georgia. When she was a year old, Anna had an undiagnosed illness that caused minimal brain damage. As a result she has static encephalopathy, with attentional disorder and processing problems.

Everyone asked me if my personality changed after the accident. It didn't really. I've always been an outgoing person . . . Mom says I could talk to a wall. What did change was my perspective on life. I was always very long-term oriented . . . the save-for-a-rainy-day syndrome. My whole life was altered in a minute and a half. Not only was I injured, but three people, including my boyfriend, were killed. That taught me that you could save and save for that rainy day, and it may never come. I've learned to appreciate NOW.

Most other things haven't changed about me, including my interests. Since the fourth grade I've wanted to work in the travel industry. By my last year in college I knew I wanted to work for an airline, and I knew I wanted that airline to be American. My first job with American was in general reservations; then I moved to the customer service desk. I loved that . . . dealing with people who are upset or need extra service. It's a good feeling to help people or to make someone who's angry go away feeling better. From there I moved to training reservationists in the use of our computer system.

Next came a special assignment on a task force to teach disability awareness. For eight months I traveled five to six days a week, in the United States and abroad. I never got tired of it, and I feel that the training was effective.

For the past two months I've been an analyst with the ground equipment technical support team. It's such an interesting area. But, of course, the time will come when I move to yet another one.

If I sound enthusiastic about my job and whom I work for, it's because I am. I'm very career oriented and I'm working in a career that I love.

However, I do want it all. I want to have a family and I want to work. When the time comes to have children, I'll cut back on the work schedule. I intend to be an active part of my children's lives, especially when they're young. I know I can find a way, though. I believe you can find a way to do just about anything you really want to do.

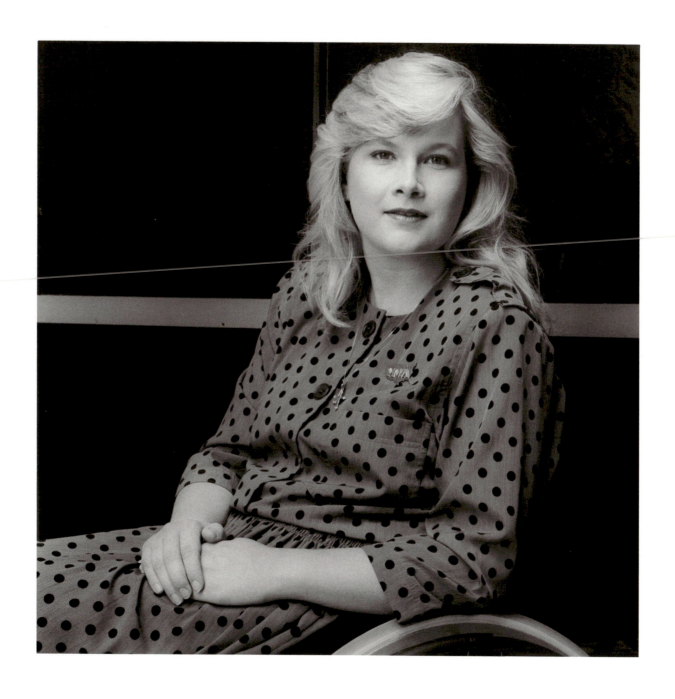

DEANNA GREENE, the 1991 Miss Wheelchair America, lives in Arlington, Texas, where she works for American Airlines. Deanna sustained a spinal cord injury in a car accident.

I grew up on a farm in Ohio. When I was ready to go to work, it was obvious that there wasn't much secretarial work in rural Ohio. So I took the civil service exam in Akron and wound up in Washington, working first for the Department of the Army, then for the Navy Department. After the war the Office of Price Stabilization was established. It fascinated me that such a department could spring up out of nowhere, really; so I went to work there before there were even pencils or paper or desks. In fact, the first thing I was involved in was purchasing supplies. As soon as we had desks for them to sit at, we hired experts in consumer goods to staff the department, and I was in "expert transportation." After that I was transferred to Poultry, Eggs, and Feathers. It was something, answering the phone, "Good afternoon, Poultry, Eggs, and Feathers."

My next assignment was the State Department. Since I was still a country girl from Ohio, I always refused when offered overseas duty. One day, though, one of the secretaries assigned to an office in Turkey quit. Again I was asked to go overseas; again I refused. But, for some reason, I started thinking it over and, after talking to my family, decided to try it. In October 1952, I was on my way to Istanbul. That was the beginning of seventeen years of travel. My work took me to Athens, Paris, London . . . where I got my guide dog of thirteen years, Polly. I vacationed in Egypt, where I rode a camel; Spain, Jerusalem, and the then Pearl of the Mediterranean, Beirut. As a result of my years with the State Department, I know people all over the world and have a head full of wonderful memories.

And now, after thirty-one years of government service, here I am, in my beautiful condominium in Atlanta, Georgia.

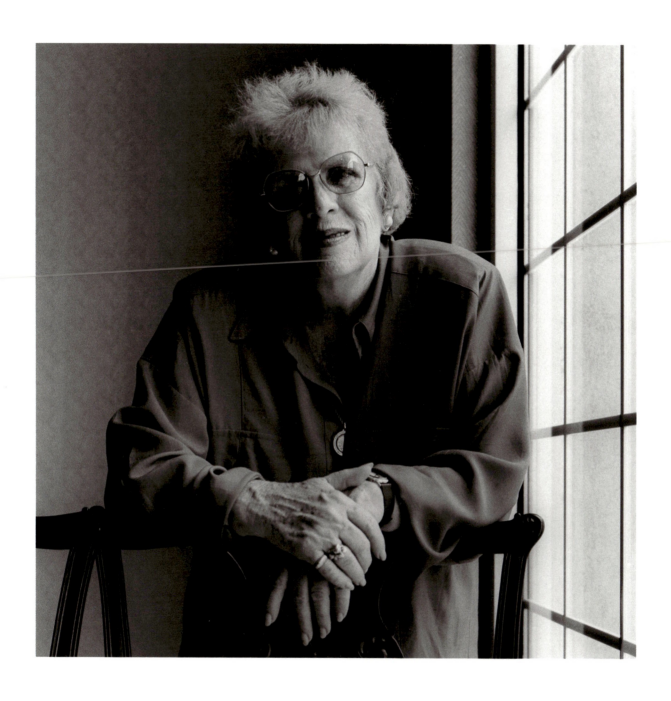

BEATRICE K. (Bea) TAYLOR is a former foreign-service employee and, until her retirement in 1973, lived in major cities all over the world. Born with glaucoma, Bea has been legally blind all her life.

SANDY CHIU

I am Sandy. I am in a wheelchair because I can't walk. And I have cerebral palsy and I have to have braces because I can't walk. My braces help me walk.

I like school. I like to make stuff. And I have a school box. And now my mama is picking me up so I can stay later in the day. I have friends at school. I like them. And I love to eat lunch at school. I love pizza!

And I like to read. I like my teacher and I like my mom. My mom is nice to me.

I have therapists that come to my house.

I like to fix hair. I like Keely and Amy

I do my work at school. We have dinosaurs at school, and if you be bad you get it turned over. And me, too!

I can still have friends, but I can't walk.

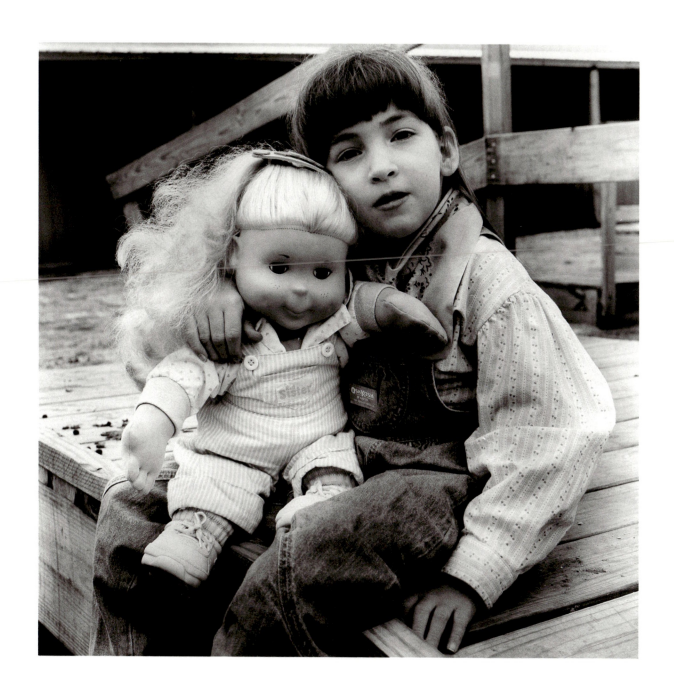

SANDY CHIU lives with her parents and two older brothers in Conyers, Georgia. She is pictured at a riding stable where she takes riding lessons. Sandy was born with cerebral palsy.

When I was nineteen I dived into a quarry, hit the water wrong, and broke my neck. The result of the injury meant a radical change in my life. It was clear that from then on I'd have to make changes in the way I did most things. What didn't change was my desire, my right, to lead a meaningful life. It wasn't too long before I learned that I wasn't the only one who needed to make changes. There was . . . still is . . . a real need for "attitude adjustment" on the part of those who have no experience with disability. The fact is that a number of those able-bodied souls have a direct impact on how I'm going to live my life. They are administrators, bureaucrats, members of public facilities boards, legislators, etc., who determine how public money is spent, what laws are passed and vigorously enforced. I also learned that attitude changes don't just happen. It's cheaper and easier to maintain the status quo. And that's how I became what some would call a militant advocate . . . or activist. You have to get people's attention and sometimes that requires extreme measures.

My commitment to advocacy began in Charlotte, North Carolina, where I was a frustrated rehab counselor . . . frustrated because I was counseling people and then sending them back into communities that were not only indifferent to meeting their needs, but that often projected negative attitudes toward disability. I knew I had to start making changes in those communities.

It was in Denver, Colorado, that I became involved with a group of very enlightened, very effective disabled people . . . real ACTIVISTS! Our issues then were about public access. We won on those issues. In 1983 we formed ADAPT, American Disabled for Accessible Public Transportation.* Now it's gone far beyond issues of access and is national in scope.

In 1986 my wife and daughter and I moved to Atlanta. I've been fortunate to work in a job that pays me to be an active advocate. I will always be an advocate because I will always be committed to getting people to care and to know they can make a difference.

*ADAPT now stands for American Disabled for Attendant Programs Today.

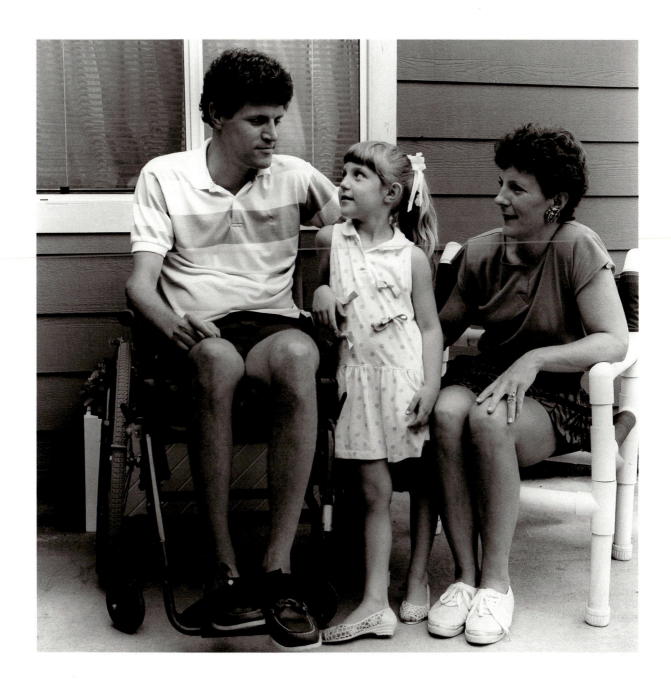

MARK JOHNSON is an advocacy specialist at the Shepherd Spinal Center in Atlanta, Georgia. Pictured with Mark are his daughter, Lindsey, and wife, Susan. They live in Alpharetta, Georgia.

By the time I was in high school I was sure I wanted to be a lawyer. After graduating from Washington and Lee in 1959, I went to the University of Virginia Law School. When I graduated in 1964 I sent job applications to thirty-nine law firms. Thirty-nine firms responded with invitations to interview; I received thirty-nine rejections on the basis of my disability. It was a devastating time for me. There was no disability movement then, but I was moved to start writing . . . articles, letters to editors of various publications. In the seventies I wrote close to a hundred articles or trailers for Jack Anderson.

My first job was in the chief counsel's office at the IRS, under President Johnson. After three years I moved to the SEC. For thirteen years I handled insurance equity products. By the end of 1976 I was handling all insurance filings. The SEC decided to set up a separate branch to handle insurance equity products and offered me a job in the branch. I thought I should head it. By then I was using a chair and was told I was too disabled for the position. So in 1977 I sued the Security and Exchange Commission and in 1979 I won the case. I stayed at the SEC a year after that. In 1980 I took the job of director at Ralph Nader's Disabilities Rights Center.

From 1985 to 1987 I worked with Ronald Reagan to locate people with disabilities to work in his administration. I was offered a position myself in 1987 and started work as a commissioner at the Equal Employment Opportunity Commission. During that time I also was working with George Bush, writing speeches and helping him reach out to disabled voters. A Louis Harris Poll documented a big swing to Bush in the 1988 election. Actually, two million of the four million votes that won the election were disabled voters.

There are a couple of things I'm especially proud of. One involves breaking a monopoly on the manufacture of wheelchairs. I'm also very proud of the fact that I helped get the White House on board with the ADA (Americans with Disabilities Act, signed on July 26, 1990). This is a revolutionary piece of legislation.

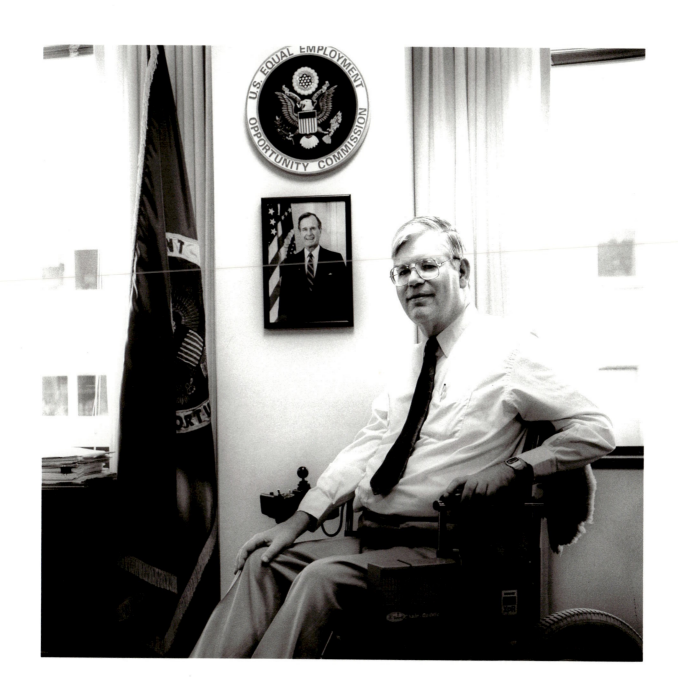

EVAN J. KEMP, JR., lives in Washington, D.C., where he is the chairman of the U.S. Equal Employment Opportunity Commission. Chairman Kemp has had a rare neuromuscular disorder since he was twelve years old.

I grew up in a small town in Minnesota. Actually Wadena, with about 4,500 people, was the biggest town around. My dad owned a drugstore there. I was the youngest of four . . . two brothers and a sister. My childhood was a pretty standard American childhood.

When I was sixteen I was injured in a diving accident and spent most of the next two years in the hospital. Then came six months at home. The year 1974 was a turning point in my life. I went to the Sister Kenny Rehabilitation Center and underwent some testing . . . I.Q., personality, etc. My sister took me out a lot, about four times a week. I was looking for a direction; the testing helped me find it. Going out with my sister helped me reengage with life. (She told me later she wanted to make me dissatisfied with being at home.) I left rehab, thinking psychology would be a good field for me.

In 1974 I applied to Southwest State University in Marshall, Minnesota, reputedly the most accessible school in the country. I was accepted academically, but ultimately rejected as being too disabled. That was pretty depressing, but I was pretty determined and that made me more so.

In 1975 I started summer school extension courses at the University of Minnesota in Minneapolis. Four years later I followed the sun to San Diego, where I could enjoy the climate while working on my honors thesis. In 1980 I was a graduate summa cum laude of the University of Minnesota.

By 1990 I had my Ph.D. in counseling psychology, but actually got a job before I finished the degree. In 1988, at a conference in Las Vegas, I met the department head of psychological services at Shepherd Spinal Center in Atlanta. He made me an offer I couldn't refuse . . . a job as a psychologist in sunny Atlanta.

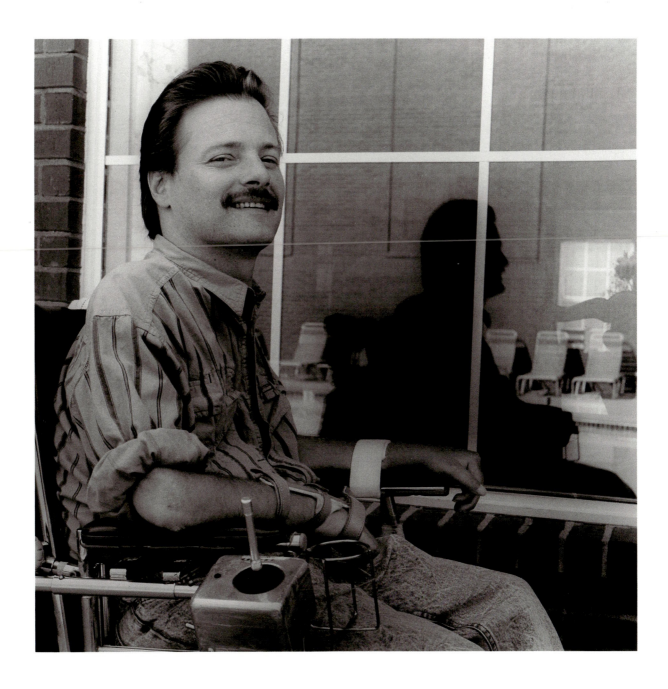

A native of Minnesota, **DR. JIM KRAUSE** now lives in Atlanta, Georgia, where he is a psychologist at the Shepherd Spinal Center. When he was sixteen years old, Jim sustained a spinal cord injury in a diving accident.

I do not consider myself special or different. I am a person who had to learn to accept things as they are and live according to each situation that arises. I have applied myself to each and every endeavor I undertook. If I wanted to learn something different, I went after it. I have done a lot of things in my life and for the last twelve years have been in hairstyling. I had a temporary setback two and a half years ago. After accepting my limitations, I received the training I needed to live as a blind person and also discovered that I was able to continue in my chosen profession. I am independent and I would like to travel and tell others never to give up their independence. Those who don't have independence are not complete as a person. Fight and never let someone tell you what to do with your life. You are someone and have the right to pursue an honest, profitable way of life. There is nothing you cannot overcome if you have faith in God and yourself.

My goal for the future is to succeed as a hairstylist and salon owner. I want to make money and get the things needed in this life to be comfortable and happy. With the help of good people like my employees and a few close friends, I can obtain that goal. Those who are in the position to do for others should try to do so without making it so hard that people give up. I may lose this salon, but it will not be for lack of trying on my part. I can be proud of what I have done. But for the interference and lack of help from those assigned to help, I have done a good job. I am not ashamed of what I have done and will do with the rest of my life.

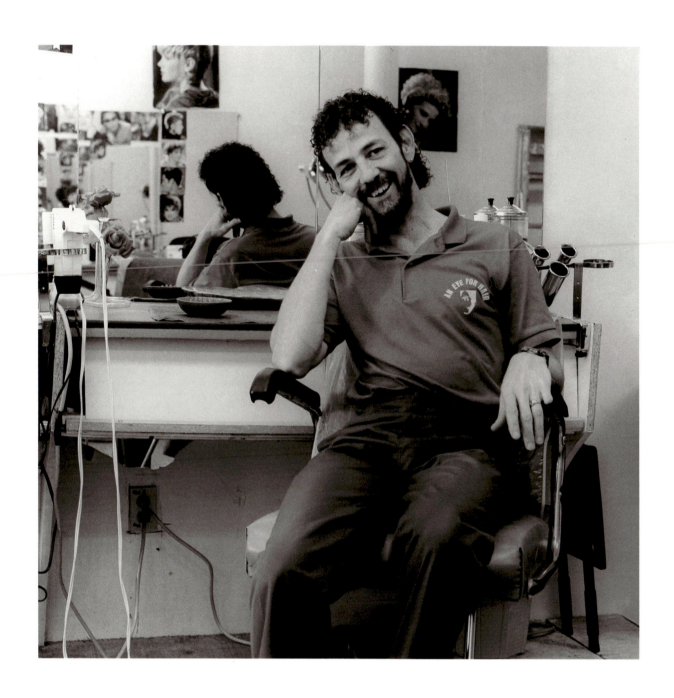

DAVID MELANÇON lives in Miami, Florida, where he is a hairdresser and a lay priest in his church. In 1988 he lost his sight in an accident.

I agreed to do this project because it seems to focus on the fact that people who have a disability are ordinary people who do ordinary things. One of the biggest problems with being different is that people tend to think you're amazingly different or pitifully different. Most blind people I know are just regular people. They get up and go to work, have hobbies, enjoy their families, take vacations. Some are nice; some aren't. People who are visually impaired are, first and foremost, people. And one of their many characteristics is the visual impairment. That's all.

I also would like to talk about one of my great interests, cross-country skiing. A friend told me about Ski for Light, which began in Norway. Sighted guides work with visually impaired people so that they can learn the joy of cross-country skiing and give them access to a more active lifestyle. Often when people lose sight they lose confidence, forego vigorous physical activity. In fact, this happens with lifetime visual impairment. Now Ski for Light includes people in chairs, as well as some amputee skiers. My involvement began in Deadwood, South Dakota, in 1982. It was 10 degrees below, and before we even started a guy slipped on the ice and broke his shoulder. I thought, "This is fun?" Of course it was . . . is . . . and it gives me a chance to do something most visually impaired people miss out on . . . the friendly competition of weekend sports. A couple of sets of tennis, a round of golf, and the losers buy the beer. Now I do that with other skiers. I also enjoy being with first-time skiers who not only enjoy the sport, but also leave with new confidence. What I really like about the program is that it focuses on people's abilities rather than disabilities. And it involves sighted people in doing things with visually impaired people rather than for them. And of course, independence is important to just about everybody.

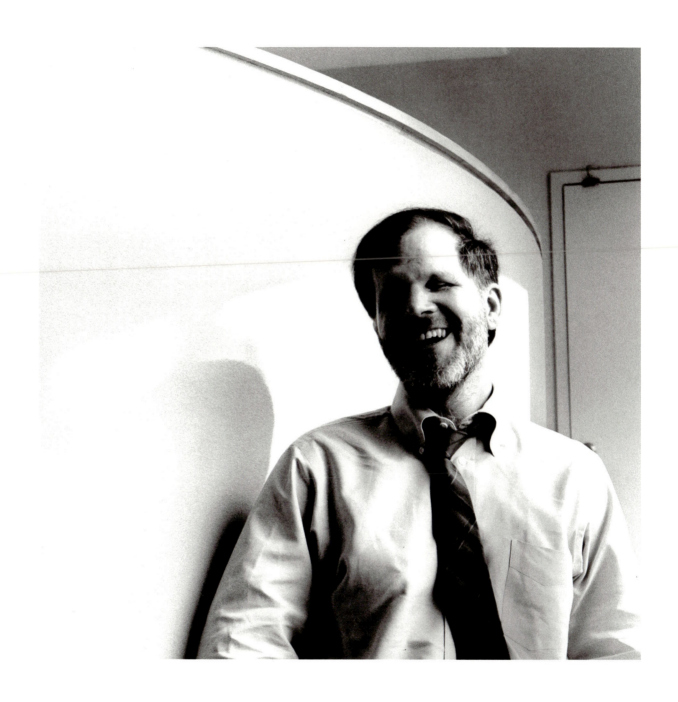

SCOTT McCALL is the director of the Center for the Visually Impaired in Atlanta, Georgia, where he lives with his wife, Marilyn. Scott's blindness is congenital.

My dad was a professor of art history. Really, he's my inspiration. He got me started. He talked to me about art, made it a part of my life. I've always . . . since I can remember . . . drawn people. Being an artist is the only thing I've ever wanted to do. And my parents always told me to go for it. They told me I could do whatever I wanted to do. I was a late bloomer because of my sight, but there was no question that I would be an artist.

So right out of high school, I went to California, the Walt Disney California Art Institute. After a year I decided to come back south. I finished art school in Atlanta, where I plan to stay.

I made choices that enabled me to be a working artist. Selling work . . . being self-employed as an artist is important. So I walk that line between being commercially successful and artistically true to myself. So far I've been able to do it. I show my work and sell it. That's really satisfying.

I want to be happy. Happiness for me is making my own world. Persistence, doing it until it's right is what I do. I tend to work in series. I'm about to start work on a series about the civil rights movement.

I'm happy in terms of where I am at the moment. And we'll just see what happens.

GENE ALLCOTT lived with his wife in Atlanta, Georgia, where he was a working artist. Gene was visually impaired because of a congenital retinal defect. He was killed in an accident in April 1992.

I live in Powder Springs with my mom. I have two brothers and one sister. I go to South Cobb Training Center. I do B-line work there, put square and round pieces of wood together, put a screw and nut on it. Then somebody counts them and puts them in boxes. We just started making swings for little kids. We put four ropes in a hook and a wooden seat with a loop. They're for playgrounds. When we aren't working, I talk to my friends, play games.

I go shopping . . . grocery, clothes. We go out to restaurants for lunch. This helps me learn independence.

I met my boyfriend at the center. His name is Jim Brannon. He helps me with work sometimes. We take breaks together, eat lunch together. We talk on the phone. I've been his girlfriend for two years.

At home I like to watch TV and listen to the radio. I like country music.

I have two nieces and two nephews. I see them a lot and I like to be with them. I like kids. There are lots of kids in the neighborhood, too. For a while I've been working with a three-year-old class at church.

Sometimes for fun I go to a flea market with my daddy. Sometimes I buy a grab-bag; I buy jewelry. I bought two little chairs for the kids.

My family and my boyfriend make me happy. My life is happy.

LAUREN KAY DURRETT lives in Powder Springs, Georgia, with her mother, Eleanor Conn. She works at the South Cobb Training Center. Lauren was born with mental retardation.

I was born, raised, educated, and seduced in Cartersville. Our family on my mother's side goes back to the 1880s in this area, just north of Cartersville, Cassville, which used to be the capitol of Georgia. My great-grandfather was the first black man in Bartow County to vote because he was a property owner. My father's people are from around Chattanooga, Tennessee. I don't know a lot about that side of the family. But the Smiths (my mother's family) have documented our family history. In 1970 we had our first organized family reunion . . . 300 or more people here in Cartersville. In 1981 I was informed that I was hosting the next reunion. A year of planning and I still had to take off from work a week to do last-minute things. I booked rooms in three hotels and the Civic Center for our major dinner. The first night I served barbecue to 250 people in my backyard. This family history . . . the reunions mean a lot. I think it gives me a strong sense of myself.

Right now I'm employed as the director of transportation for Bartow County . . . 1,100 miles of road and six vans. Our target populations are senior citizens and what we call "transportation-deprived citizens." Some of these people couldn't get out to the doctor, grocery, drugstore, without this service. And we NEED MORE VANS!

I'm involved in a number of public service organizations, but the one that means the most to me is the Georgia Council on Developmental Disabilities. Being on the council, knowing some of the right people means that sometimes I can make a phone call and make a difference in someone's life. That means a lot to me.

ESSIX RICHARD III is director of transportation for the Bartow County Transportation Department in Cartersville, Georgia. He sustained a spinal cord injury at the age of seven when a car hit him.

CHARLES and JANIE PENLAND

Note: As I neither sign nor understand ASL (American Sign Language), Chip Penland served as interpreter during my conversation with his parents.

CHARLES — I am one of five children; I was born in Blairsville, Georgia. When I was very little, we moved to Michigan. That's where I started school and found out that I was deaf. At that time not much was known about education for deaf children. My family moved back to Georgia and I started school at the Georgia School for the Deaf. After thirteen years there I graduated and got a job in a fender and body shop. Not long after, I started working at the new U.S. Post Office in Gainesville. That was in 1969 and I am still working there. Then I was the only deaf person there; now there are five deaf people and some of the hearing employees have even learned some ASL.

In 1972, I went to a basketball tournament. I got so excited, cheering for my team, that I hit the girl in front of me on the head. That girl was Janie Wagner. After ten months of driving between Gainesville and Knoxville, Tennessee . . . many letters, too . . . we were married on November 17, 1973. Our son, Chip, was born in 1976 and Lindsay, our daughter, was born in 1979. Both learned to sign before they learned to speak.

One day we were in a grocery store and I was talking to Chip. He must have been speaking as well as signing, because a strange woman came up to us and said that she had heard of an operation that restored hearing to deaf people and why didn't I have one? I told her that I knew about that operation and that it cost thousands of dollars. Why should I pay that kind of money just to hear . . . besides I would have to learn everything over. I am happy the way I am. And I'm happy with my life. It's a very good life.

JANIE — I am also one of five children. I was born in Carlsbad, New Mexico, but my family moved around a lot. My deafness was discovered when I was three. My parents had a very hard time accepting it. They tried everything . . . hearing aids, public school where I was forced to learn to speak. That was very hard! Finally, at age nine, I was enrolled in the Tennessee School for the Deaf. That was where I discovered my love for theater. My first role was Snow White, and I thought it was fun. But every time I was on stage after that, I loved it more and more. When I was eleven I convinced them that I could sign "The Night Before Christmas." People thought I couldn't do it, but I did. Oh, I love drama . . . I did everything . . . directing, acting. My senior year I added mime to my drama skills. In fact, I thought seriously about drama as a career. But I also wanted a family and I didn't think the two would mix. Still it's a dream of mine to establish some kind of company locally.

Right now though, my job and my family take up so much of my time. I'm a paste-up artist for the *Gainesville Times*, and I teach ASL on a partly volunteer, partly paid basis. When I do have some spare time, I enjoy various kinds of crafts.

CHARLES and **JANIE PENLAND** are congenitally deaf. Their children, Chip and Lindsay, are hearing. The Penland family lives in Gainesville, Georgia, where Charles is employed by the U.S. Post Office and Janie works for the *Gainesville Times*.

I've been working since I was nine . . . give me a job and I'd do it. From the time I was twelve I helped my daddy in his business, Austin Mobile Home Service, setting up mobile homes. When I was eighteen I started working as a backhoe operator. Mostly we installed septic tanks . . . did some sewer lines, water lines. I did love working that backhoe!

I had my accident in 1989. I've had twenty-two operations and spent several months at Warm Springs (Roosevelt Institute). They taught me how to walk and I love them for it. I couldn't believe it when I came to and wanted to get out of bed and they told me I didn't have any legs. But eleven months later I had a prosthesis and could walk around. I use the chair a lot because it's easier . . . and safer. I can take a fall on the crutches.

For a while after I got home I didn't do much . . . no job. But I wanted a job. My brother-in-law told me about the one I have now. When I heard about it, I went to talk to Mr. Chester and he hired me. I've been at Dawson Saws a while now and can fix any Snapper mower that has a problem. I've still got a lot to learn, though. What I'd like to do is stay at Dawson's until I've learned all there is to know and then start my own shop.

Of course some things have changed since the accident, but most things haven't. I still love to shoot pool, love to fish and hunt. I knee-board behind a boat . . . just like water-skiing. I did it my first try. I'm no cripple; I refuse to be. I mow the grass, ride my buddy Jerry's Harley with him. And I have my own four-wheel motor vehicle that I ride.

I've accepted what's happened to me. I don't care who you are when you lose something, you've got to understand that it's gone and deal with that first, then get on with your life. I could do that because I've got a mom that loves me to death and a God that thinks a lot of me . . . and, I guess, because I'm the kind of person that won't give up.

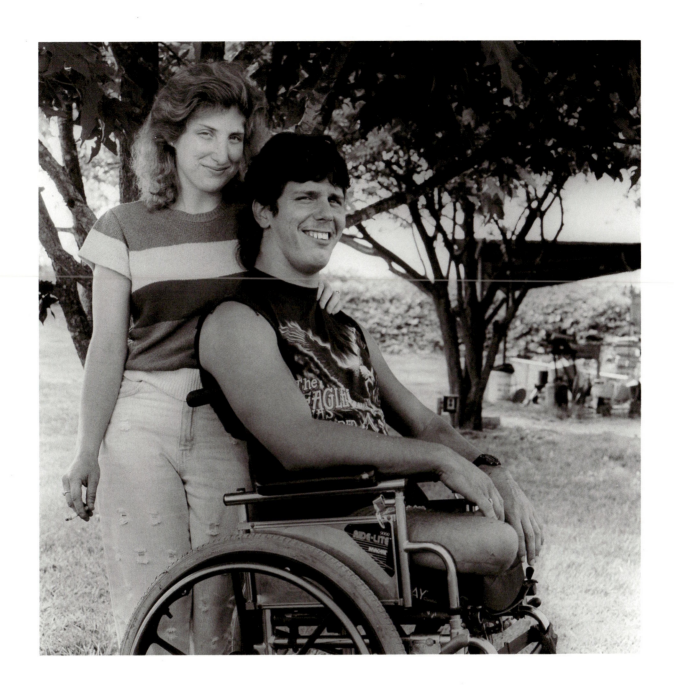

RODNEY HOOKS lives in Byron, Georgia, where he repairs small motors. Rodney's legs were amputated when he fell on a railroad track and was hit by a train. He is pictured with his girlfriend, Kelly Buck.

I grew up in a signing environment. My parents, who were deaf, always signed to me. My Aunt Marion and Uncle Clyde were deaf, too. And so were their friends and the friends of my parents who came to visit us. My five cousins, though hearing, either signed or gestured to me. This was my world and I could not conceive of any other.

One day when I was two and a half years old, I realized there was a much greater, hearing world around me. This awareness came when my mother sent me to the neighborhood candy store two doors away to buy a pack of cigarettes for her. I entered the store with money for the cigarettes and a note for the proprietor, who looked at me and started to move his mouth. He did not sign at all. He read the note, gave me the cigarettes and change, and kept moving his mouth at me as I left. It was thus that I made the discovery of my deafness. That trip to the candy store was my first direct realization that there existed another class of people, the hearing, the ones who ruled this world. I did not question this difference; it just was there. I thought deafness was a way of life and never linked it with sickness, defectiveness, or a handicapped condition. I thought, and I still do, that my deafness is just part of who I am.

My father was an actor and director in a nonprofessional company that performed for deaf audiences. I began acting as a student at Gallaudet University. I spent a summer studying with the great mime artist Marcel Marceau. My career has been long and full, with thousands of performances all over the world. I cofounded the National Theater of the Deaf and have known the joy of seeing that company reach international acclaim. Now I teach young actors at Gallaudet. I encourage people to stretch themselves, to interpret with their faces, hands, and bodies. It has always been my objective to help achieve open-mindedness toward our (deaf) culture, as well as open-eyedness to our visual communication.

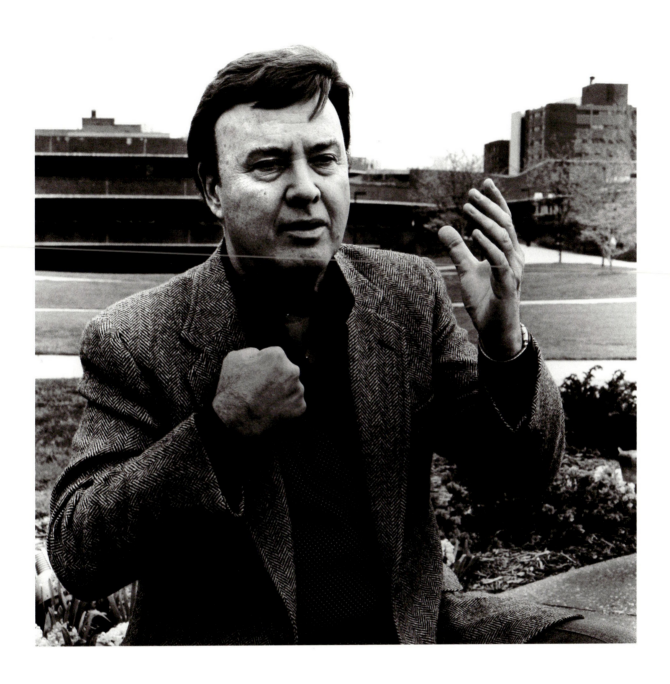

BERNARD BRAGG is congenitally deaf. He is an actor and the cofounder of the National Theater of the Deaf. He is a consultant and professor at Gallaudet University in Washington, D.C., and continues to perform one-man shows around the world.

Thirteen and a half years ago I was a busy mother of two sons. Rob was seven and a half; Bryan was a year and a half. My life . . . our family's life . . . changed drastically when I had what I assumed would be a short-term virus. By the time it had run its course I was a quadriplegic. My family rallied around me. My husband, Bob, was a wonderful help. My mother took a year's leave of absence from work; Bob's mother pitched in. I had extensive physical therapy that helped me regain the use of my hands and arms. I'll never forget that a real highlight was when I was able to pin my baby's diapers.

I've always been a person of determination. And I was very determined that this situation was not going to undermine our family, that our kids would grow up in a "normal" household. And I was looking for something to do. In physical therapy there were candy-making classes. I decided to try that. During holiday season our kitchen was a candy kitchen. I worked round the clock and made hundreds of pounds of chocolate candy. I was a one-person candy business for about six years.

In 1985 Bob heard about wheelchair tennis and thought I might enjoy it. He was right. I enjoyed it from the first time I picked up the racket. Bob became very involved. He formed the Ohio North Coast Wheelchair Tennis Association (now the Cleveland Wheelchair Tennis Foundation). He has played . . . still plays . . . a big part in my tennis life. Our sons are very supportive. And they have enjoyed some aspects of it. Going to tournaments has enabled us to do some traveling as a family.

In general we are like most families with full lives, collectively and individually. And we are a very happy family. I suppose it could have been different, but we took a potentially devastating situation and pulled some good things out. I think we all agree that a lot of very positive things have come along since 1978.

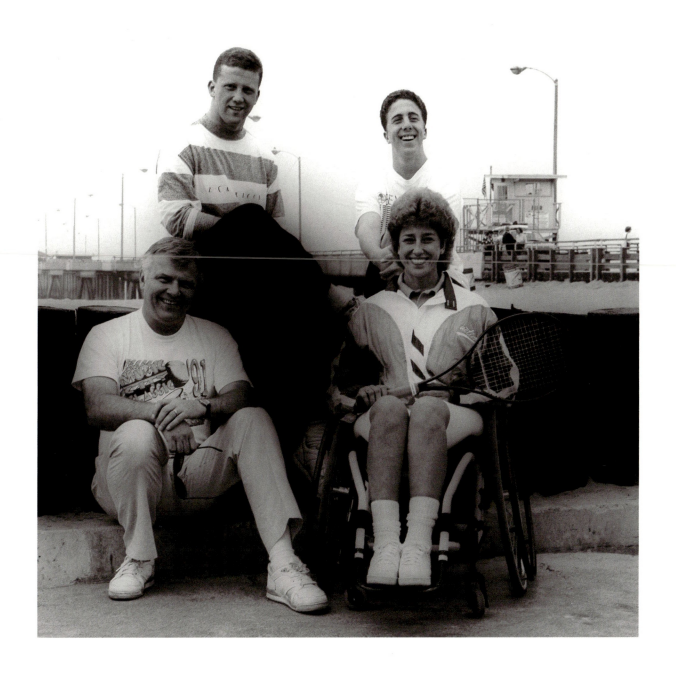

KAREN HIXENBAUGH and her husband, Bob, live in Maple Heights, Ohio, with sons Bryan and Robert. Karen is an avid tennis player and is active in her local wheelchair tennis association. In 1978 she had transverse myelitis and as a result uses a wheelchair.

When I was eight I saw a guy on the Grand Ole Opry playing a pedal steel guitar. I told my parents I wanted to do that, so for Christmas they gave me a beginner guitar. That summer I took lessons at the local Boys Club. A very sympathetic gentleman named E. C. Daniels helped me develop my somewhat unusual overhand style. He devised a way, using a Hawaiian nut and a guitar slide, for me to play. I took to it right off. It really was a gift from God. That first year I could play, I was performing to raise money for the Boys Club.

I joined my first rock band at fourteen . . . Blackberry Winter. That year we won the Battle of the Bands for junior high. We beat out a lot of popular kids and suddenly I was accepted. That convinced me that no matter what odds I faced, in music I had a gift from God and could do about anything I set my mind to. Blackberry Winter got a real reputation . . . had gigs all over town and away, too. But after four years we went our separate ways.

In high school, besides being in the band, I was a deejay . . . the only white with an all-black station. On the radio I was "Fast Eddie." That's the name on my business card today.

For the past twelve years I've been working in sales in music stores and playing with various bands. The last one played progressive country.

Last summer I developed carpal tunnel syndrome in my right arm. I had surgery twice. This has been a very painful deal. And I had to give playing a rest. But now I'm reconditioning my arm, getting back into playing, and making plans for my musical future.

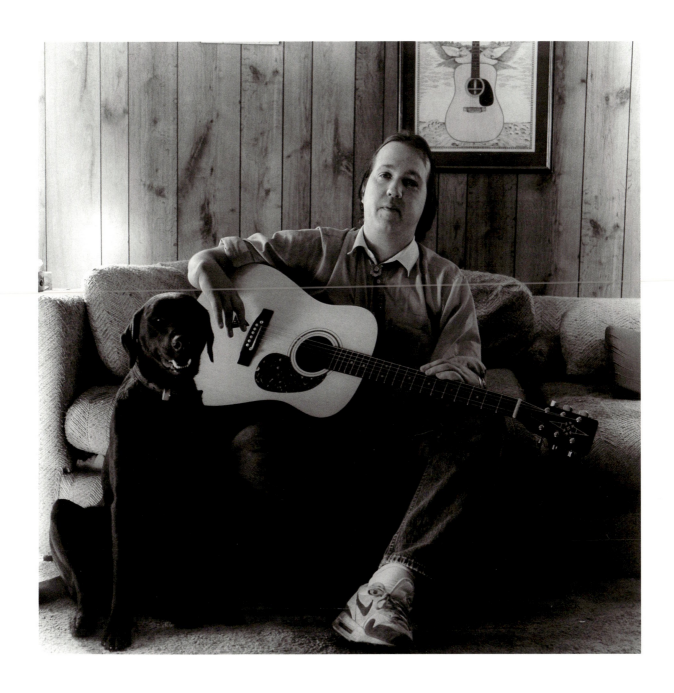

ED HUNT is a musician in Knoxville, Tennessee. During her pregnancy, Ed's biological mother (he was adopted as an infant) took Thalidomyde, causing Ed to be born without thumbs and wrists.

JANE MAZUR — My sister and brother live in Atlanta; I see them holidays, weekends, sometimes. The rest of the time I live with my friends. I love my friends here! I work at Herman Miller, where they make furniture. Now I am gluing furniture pieces together and I like that job a lot. When I'm not working, I love to look at *TV Guide*. And I like listening to music and coloring.

KATHY SULLIVAN — My family . . . mother, stepfather, brother, and sister, live near Atlanta and I live at Barrington Landing. I really love the people here. We mostly get along real well. I'm supposed to move my room into the basement soon . . . and I'll have more privacy. I work at the Haynes Bridge Kroger where I make pizzas in the deli and help Chris (Eckman) in the bakery if I can. Right now we need more people to work at Kroger. I like to ride my exercise bike, listen to music . . . mostly rock and roll. At night I do what I need to get dinner ready and clean up. Then I relax, watch TV.

CHRISTINE ECKMAN — My parents live in Atlanta and I have a sister in New York. For three years I have lived at Barrington Landing with Sasha, the cat; RoseBary; Jane; Kathy; and now, Tanya (resident manager at the time). I'm happy here. I work at the Haynes Bridge Kroger. I bake cookies and some bread; I enjoy baking cookies the best. My friend Kathy works there, too. We eat lunch together when we can. At night I watch television, listen to music . . . many kinds of music. I like to sing, too. Every night I write in my diary about my day.

ROSEBARY TRAMMELL — Mom and Dad live on East Wesley Road in Atlanta. My brother lives near Atlanta. Whenever I can I see my family, but we're very busy at Barrington Landing. It's almost three years since I moved here. I love Jane and Kathy and Chris. And I like this house a lot. I work at RRA (Resources for Retarded Adults), helping with the cleaning. I also go to the training center and do different things. This Christmas we're helping the homeless and the needy, giving food; and I took some pennies to school today. I like to read my encyclopedias, *Reader's Digest*, things like that. I ride my exercise bike sometimes, and when the weather is nice, I like to take walks and talk to the neighbors.

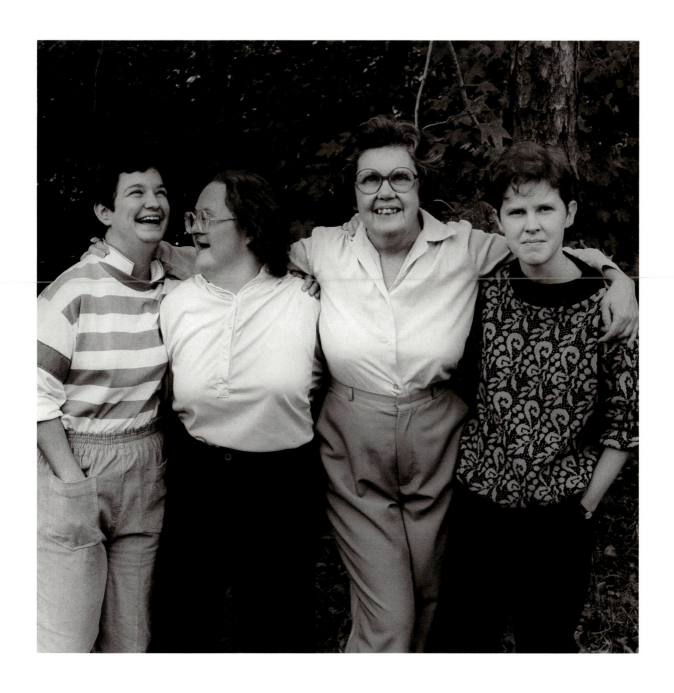

Pictured from right to left are **KATHY SULLIVAN, JANE MAZUR, ROSEBARY TRAMMELL,** and **CHRISTINE ECKMAN**, who were born with various types of mental retardation. All are employed and live with a resident manager in a house in Roswell, Georgia.

I'm a lot of things rolled into one package: Laughter and tears, triumphs and defeats, dreams and disappointments, foolishness and wit, self-concern and willingness to sacrifice for others. Sometimes I wonder how I manage to balance so many differing abilities and disabilities. I'm proud of my American heritage and humble before those who have prevailed without my advantages.

I'm a strong, intelligent, principled, articulate, and very stubborn woman (who happens to be blind, partially hearing, and a wheelchair user) who will probably continue to fill roles I consider essential in the struggle to create opportunities and allow my species to fulfill its potential.

I started out with all the obvious gifts life had to offer. I was born to young parents who cared about racism and a religious life and lived in small northern Illinois towns where my father published a small newspaper. Both shared responsibilities for ministering to small congregations within the Rock River Conference of the Methodist church. I gained my sense of women's roles when my mother assumed total responsibilities following the death of my father when I was six. From my family I gained an inquiring mind, a strong, attractive body, a sense of moral obligation to others, an orientation toward art and literature, and a life-long interest in ideas and education.

With such unlimited possibilities I learned to be complacent. The miracles which life holds became apparent only as I personally began to explore the all-too-common experience of evolving flaws. The mysteries of human vulnerability and the strength of the human spirit to survive and thrive have been a fascinating puzzle for the last few decades of my life.

Several years ago it became evident to me that the risks and stresses of the living process itself bring assorted impairments but also awaken one to the evolving joys of life. Therefore, I recognize the power of experiences I would never have selected for myself. Through them I have gained a firm knowledge of the power of the human spirit and its drive toward self-determination. The weakest among us is empowered by a dream of possibilities and the gift of "being."

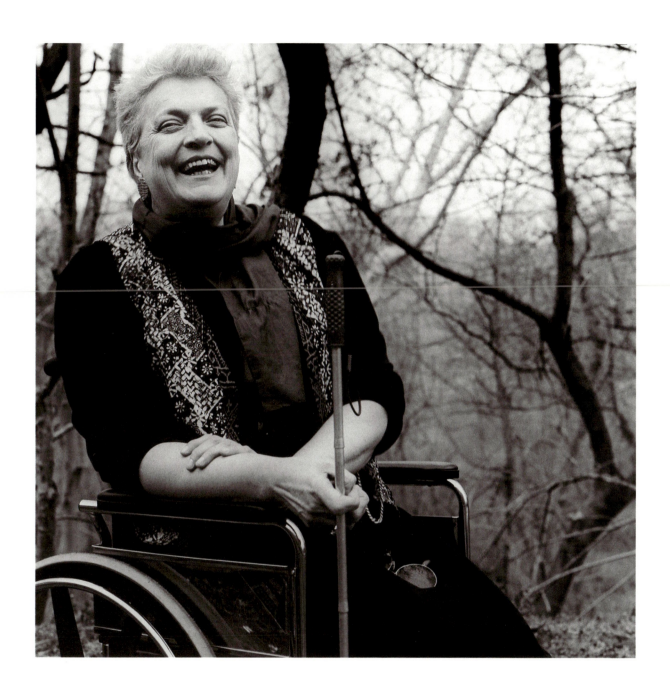

MARY JANE OWEN lives in Washington, D.C., where she is executive director of both Disability Focus, Inc., and the National Catholic Office for Persons with Disabilities. She also works as a freelance writer and public speaker. Mary Jane's loss of sight in 1972 was the result of a hereditary ophthalmic disorder. An inner-ear dysfunction caused hearing impairment and severe loss of balance, which requires her to use a wheelchair.

TOMMY CLACK

My chosen profession was the military, but I was wounded in Vietnam in May 1969. In September of that year I retired from the army as a captain. Following my injury I spent twenty-one months in hospitals. It was during this time that I decided that public service was a way to put my particular abilities to work. From around February 1971 until 1979, when I was offered the job of staff assistant to the director of the Atlanta V.A. Hospital, I was on the road as a full-time volunteer. I traveled America organizing people, projects, programs in local communities, on state and national levels. I helped run political campaigns and did a lot of speaking for churches, schools, businesses and civic groups on Americanism, volunteerism, the Vietnam experience.

Somewhere in there, between 1972 and 1975, I finished my college degree in business administration . . . did a year of graduate work before I decided I didn't need a master's degree.

I got tired of being on the go so much and took the job at the V.A. Hospital. That's where I met my wife, Cheryl. We ran around in the same group, became friends; then it got serious. We decided to try living together. That worked out well, so in 1983 . . . September 3 . . . we got married. Our first child, Adam, was born December 5, 1985. Erin, our daughter, was born September 21, 1987. I'm home more now than I ever have been because I really value the time with my family.

Cheryl and I are both very busy people and we have to swap off our time a lot. Some weekends I have the kids the whole time and I love it. I intend to be the best father, the best life partner I can be. That's my highest priority.

I still do a lot of speaking and motivational seminars. I hold volunteer positions in a number of veterans' organizations. To tell the truth, I've gotten my share of awards for my volunteer service. But I'm always reminded of what the American essayist John Ruskin said, "Man's greatest reward for his toil is not what he gets for it, but what he becomes by it." For me, that is definitely true.

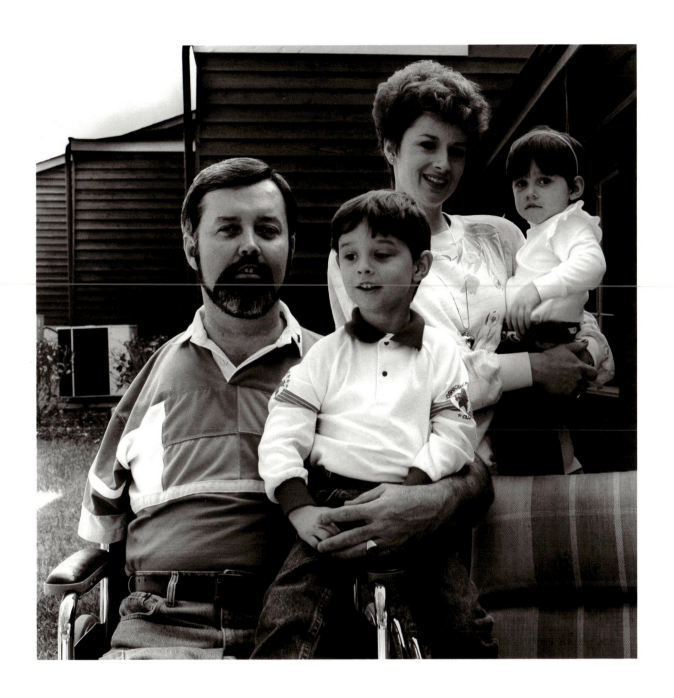

TOMMY CLACK is assistant to the director at the V.A. Hospital in Atlanta, Georgia. He is pictured with his wife, Cheryl, and their children, Adam and Erin, at their home in Stone Mountain. He lost his legs and right arm while serving in the army in Vietnam.

From the moment of my birth my parents set the standard for treatment of Julie Reynolds . . . just like any "normal" child. In fact, all my life I've been surrounded by a network of care and support . . . God, family, and friends.

In high school I was a typical teenager, having a wonderful time and driving my parents crazy. I definitely had my walk on the wild side! The summer after my senior year, my spirit of adventure really got me in trouble. One hot day, a bunch of us organized a water-skiing party. The boat bounced across a wake and I bounced with it, breaking two bones in my left leg. That postponed college a quarter. I started at Gainesville Junior College in the winter of 1973, managed to break the same leg again, and tried again in summer school. After a year there I transferred to Brenau College, where I started as a sociology major but changed to journalism. I pledged Tri Delta sorority and lived at the Tri Delt house my senior year. It was great!

In 1976 I took a job as coordinator of the ministry of caring for the First Baptist Church of Gainesville. After three or four years there, I decided to go into teaching and went to Covenant College in Lookout Mountain, Tennessee, where I got a teaching certificate. An automobile accident interrupted my stay at Covenant, but I finished by correspondence. I didn't get a chance to teach right away because I had a stroke that set me back for a while. This happened when I was twenty-nine, so turning thirty was no big deal . . . I was just happy to be here! In 1983 I did get to teach for a year at a great Christian high school in Hopewell, Virginia.

Since 1985 I've been back in Gainesville, tutoring kids, mostly fourth grade, with problems in language arts. It's some of the most challenging, rewarding work I've done!

I look back over my life and think how blessed I've been to be "mainstreamed" from the womb. Thanks to a growing understanding of God, I see my handicap as a privilege, an opportunity for God's glory to be manifested. I believe that this gift I have been given brings with it the responsibility of communicating to others how valuable they are.

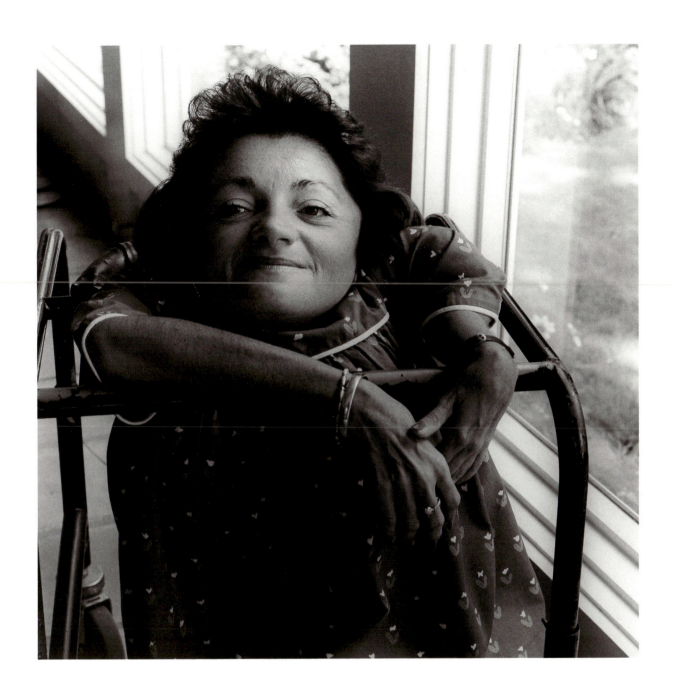

JULIE REYNOLDS was born with osteogenesis imperfecta, a condition that results in extremely fragile bones that frequently break. Julie was trained as a teacher and is currently working on a tutorial basis with children who have learning problems. She and her family live in Gainesville, Georgia.

I have been working since I was in high school. Then it was helping my dad in his office. Now I have a great job! I just started this spring (1990) as a media relations manager at the Shepherd Spinal Center. Journalism was my major and since graduation I've worked in p.r.-related jobs, but this one gives me a much broader experience in media work . . . television as well as writing.

Let's see . . . In 1982 I was a contestant for Miss Wheelchair Georgia. I must say that this is not a beauty pageant. It has to do with personal accomplishments since (your) disability. As Miss Wheelchair Georgia I did a lot of public speaking and "consciousness raising" on the subject of disability. Anyway, the executive assistant to the governor (George Busby) was at the pageant and asked me to come to the governor's office to talk about working there as an intern while I was in college. So from 1982 to 1986 I took classes at Georgia State in the morning and worked in the service of two governors (Busby and Joe Frank Harris) in the afternoon.

After I stopped working in the governor's office, I did a public relations internship on the Georgia Council on Developmental Disabilities. That was a terrific learning experience!

Right now I'm in graduate school and will finish in 1991. I hope the graduate degree will enable me to expand the responsibilities of this job to include marketing.

I guess I sound very career oriented. And I certainly do love to work. But someday I intend to have a family. Then I'll find a way to work that will accommodate my career as a mother . . . freelancing or something.

For the time being I'm single . . . more single than I've ever been, in fact. And I'm enjoying life immensely.

LISA CAPE lives in Atlanta, Georgia, where she is the public relations manager for Shepherd Spinal Center. When she was eight years old, a lipoma tumor damaged her spine.

My youth was spent in West Hartford, Connecticut. I was very involved in sports as a boy. In junior high I lettered in baseball. I was a pinch hitter. When the bases were loaded I'd go in and get a walk for our team . . . a strategy that made the other team furious. I managed the basketball team and, in high school, wrestled. My size was an asset as a wrestler. The others in the 103-weight class were tall and spindly. I was short and stocky, with a low center of gravity, and could wear them out and pin them.

And I did the sixties thing, with the long hair and required hippie dress. I went to Woodstock. After college I read Hesse's *Siddhartha*, was searching myself, and ended up in Florida. While I was there I had a Christian born-again experience and moved on to San Antonio (Texas) to Bible college. In San Antonio I met Sheryl and we married.

Nine years ago friends who had a church in Atlanta asked me to come work with them. I have since found a very satisfying job in the secular world, doing computer graphics. I design overhead slide presentations for corporations. With my background in graphic arts it's a great job for me . . . working on a MacIntosh is just wonderful. My goal, though, is to own my own MacIntosh and work at home.

Recently I became involved with the Southern Order of Storytellers and the National Association for the Preservation and Perpetuation of Storytelling. An interest in the art of story-telling is becoming a passion, and I want to make time in my life to develop it as a profession. Working at home would make that a little easier. At this point I have a very small repertoire of stories. A wonderful source of stories for me has been the NAPPS storytelling festival in Jonesboro, Tennessee. It's a fantastic experience . . . folktales, myths, legends that have been passed on and on in time. There is no script to follow. I believe that storytelling has plucked my heartstrings in such a way that all I did before can lead into my doing it full time. I must support my beautiful family and will continue working in graphic design. But with work and planning I believe I will be able to continue in the field of graphics and develop as a working professional storyteller.

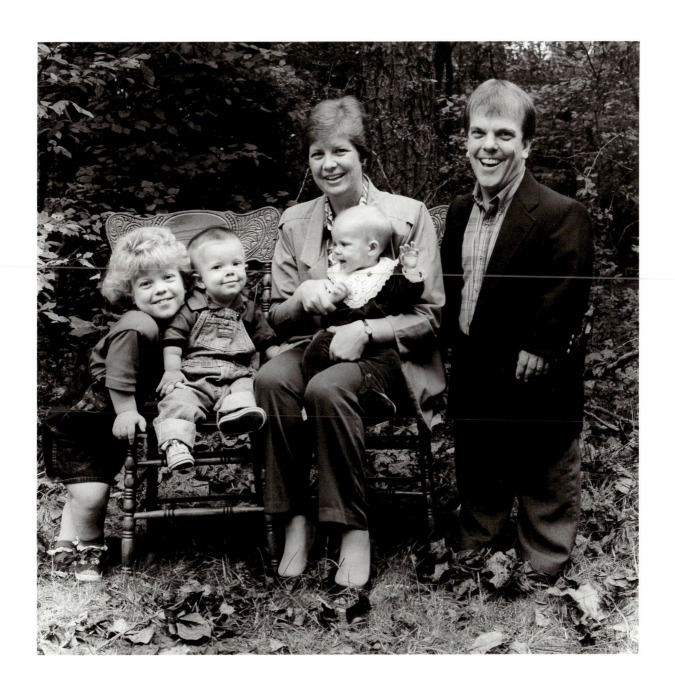

DON ROSS, a graphic designer and professional storyteller, lives with his family in Decatur, Georgia. Pictured with him are (left to right) Tova; Houston; his wife, Sheryl; and, on Sheryl's lap, Eustacia. Don is an achondroplastic dwarf.

For a while now I've been doing work that often puts me in the public eye . . . newspaper articles, etc. Often people focus on the disability. They write me up as this phenomenal woman who has accomplished so much in spite of having a disability. And that's not right. Sure I had polio, but that just happened. If I'm an achiever it's because of the role models I had in my parents and grandparents. Growing up on a farm . . . being "in the country" had a lot to do with who I am. My grandfather was an enormous influence in my life. He was an educator as well as a local and state politician. And he was a Southern gentleman. He taught me the importance of the political process and instilled in me a love of politics and my state and country. My grandmother was another great influence. She was a teacher; she was not a homemaker. In the mornings she pulled on her overalls and did the farm chores while my granddaddy fixed breakfast. Then they went off to school together. So I grew up without the traditional notion of male and female roles. And my parents reinforced my ideas. My mother often worked as hard in the fields as my father. They passed on the philosophy that people are people and it's okay to choose whatever you want for yourself.

I really wanted to be a trial lawyer, but I married early and had a baby. There was no time or money for law school. I ended up teaching instead of litigating. And I loved teaching. For five years I taught history and English . . . sometimes geography.

I left teaching to help edit a human service manual on training state human service employees. I did the training and used the experience in editing the manual. I also used that program to train workers in a program that provided day service to people with mental retardation. And there I was, on the human service track . . . where I've stayed.

In 1991 I was asked to be on the Board of Directors of the Roosevelt Institute in Warm Springs, Georgia. This means a great deal to me because Warm Springs was . . . is . . . such an important place in my lie. Between the time I was diagnosed with polio at age five and my seventeenth birthday I spent seven summers there. Such memories! There was pain, yes . . . surgeries, body casts . . . but mostly we were kids, doing whatever kids do. I remember playing chicken on gurneys (assisted by dare-devil attendants), sailing 45 RPM records out our windows to the quadrangle below. I made good friends and we had good times!

ZEBE Y. C. SCHMITT, who had polio at the age of four, is executive director of the Georgia Council on Developmental Disabilities. Zebe and her family live in Atlanta, Georgia.

I come from a big family . . . there were six of us. When I was growing up I was a typical kid . . . doing typical kid things. When I was fourteen or fifteen I knew what I wanted to do. My big brother was in the navy, and I wanted that, too. I wanted to join the navy and work with jets. I loved jets . . . still do. In fact, my ultimate dream is to ride in an F-14 Tomcat. Anyway, I signed up six months before I graduated from high school; as soon as I graduated I was on my way. It was great, working on those F-14's. It didn't last near long enough, though. About four months after I shipped out something happened to change my life forever. In a bizarre accident, I was sucked into the intake of a jet engine (F-14). The next thing I knew I was back in Ohio at the Cleveland V.A. Hospital. I spent nine or ten months there before I went to my parents' house to live. For the next several years I was just trying to regroup and put my life in order. I have to say that I couldn't have done it without my family. They really stuck by me through the bad times and helped me keep going.

I had bought a house and was renovating it when I met Pam. Very romantic moment in the parking lot of a bar. When the house was finished I asked her to move in. A year and a half later we were married. Our daughter, Becky, was born six and a half years later . . . she's a real cutie. It's been nine years and we're still going strong. Pam and I make a good team.

Four years ago a guy introduced me to wheelchair tennis. It was rough going at first, but I really love it now. I'm ranked among the top ten quadriplegic players in the country. I play between four and six tournaments a year. We're real serious about tennis on the court. Then off the court we're real serious about socializing. You make really good friends at the tournaments.

When I'm not playing tennis, I do volunteer work with some public service groups, do contract labeling for the Defense Department. I like to fish . . . wall-eye and perch.

My life isn't perfect; nobody's is. But I look around and realize that it's better than a lot of lives. There are a lot of people who don't have a close family like mine, good friends like mine, or the chance to do things like play tennis. Now if I can just hitch a ride in an F-14!

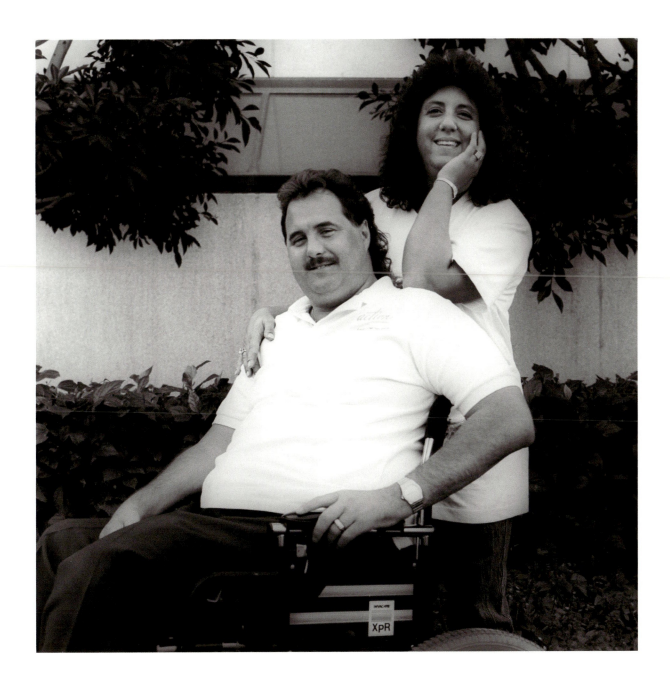

ANDY ADAMS and his wife, Pam, live in Mentor, Ohio, with their daughter, Becky. An avid wheelchair tennis player, Andy is self-employed and volunteers with various service organizations. He sustained a spinal cord injury in an accident while serving in the navy aboard an aircraft carrier.

I'm Cindy Smith and I just had a birthday! My birthday was September 13. I had a party at school . . . had a birthday cake . . . chocolate . . . and my friends sang Happy Birthday to ME! I got Baby Secret and a nurse uniform. I got kitchen presents . . . a mixer and a coffee pot, a blender. I got a hamburger, catsup, mustard, tomato, and lettuce and pickle. I like to play kitchen.

I love *Sound of Music*! I AM Maria and I sing. I have lots of dolls . . . Patty, Baby Secret, Angel Baby, Tina, Tabatha.

I do gymnastics at school. I bend, tumble, balance on the beam . . . floor exercise. I do Special Olympics. Last time I got three medals. I like Coach Green . . . he's a man. He's a very good coach and I love P.E. with Coach Green.

I have Mom and Dad and Jeff and Cindy in my family.

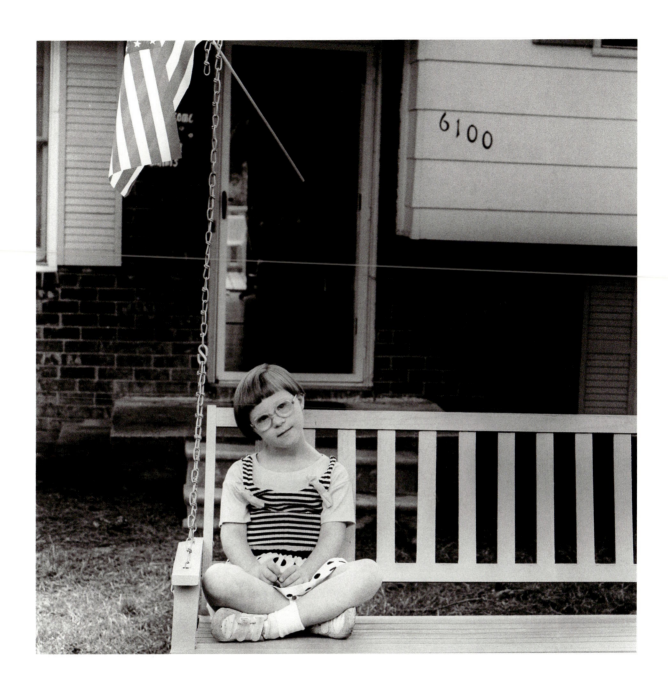

CINDY SMITH lives in Ellenwood, Georgia, with her older brother, Jeffrey, and their parents. Cindy was born with Down's syndrome.

Several years ago, when I was hurt, the other kids didn't make a big deal of it when I went back to school. They still don't. I have some really great friends and we have great times together. But there are a number of things that I like about being in high school. This year (1989) I'm a sophomore. So . . . I'm on the editorial staff of our yearbook, *The Warrior*. I'm one of the people responsible for the design of the yearbook; I also design motifs, do a little editing . . . whatever is needed.

The yearbook work is really good, but I especially like being on the Toss-Up Team . . . that's our academic competition team. We meet twice a week to practice, but mostly you just have to read a lot and keep up with current events to prepare for matches with other teams. We have to try out every year for Toss-Up. I hope I can make it every year until I graduate, and then I'd like to continue in college on a college bowl team. I guess I have to say that the competition is what I really love about it.

Another thing I really like is basketball . . . professional basketball. My teams are the Detroit Pistons and the Atlanta Hawks. I guess home-state loyalty gives the Hawks an edge on the Pistons for me, but they're both great teams . . . very different teams.

When it comes to academics, the areas that interest me most are biological science and computer science. In the seventh and eighth grades my enrichment teacher turned me on to an IBM computer . . . I loved it! Working with computers seems to come easily to me most of the time; when it doesn't, I enjoy the challenge. Computer science is definitely a career choice I consider for fantasy. Right now I keep my stories to myself, but someday I want to be a published writer . . . I wouldn't mind a career like Stephen King's! Of course, I could do something in the field of computer science AND be a writer. Well, I've got a little while to think about it!

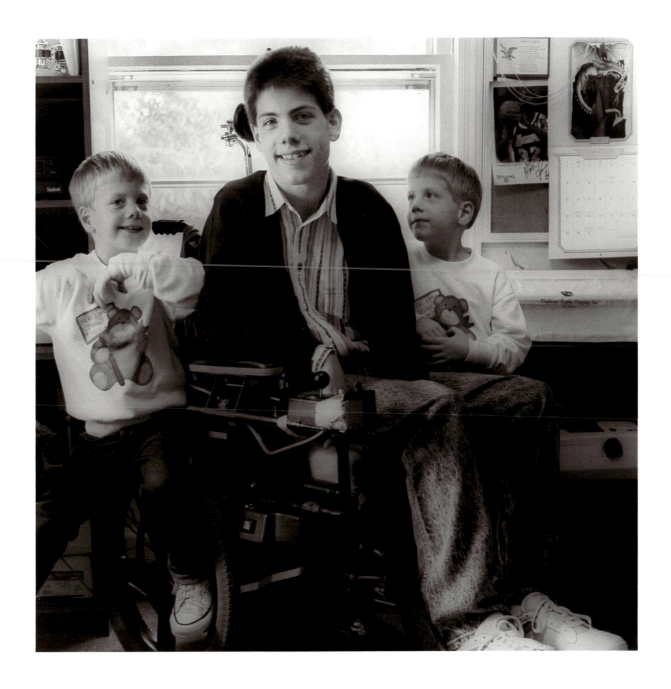

PAUL GUEST lives in Rossville, Georgia, with his parents and younger brothers Bo and Clay (pictured here) and Chan. He is currently a sophomore in high school. When Paul was eleven, he sustained a spinal cord injury in a bicycle accident.

I'm thirty-one years old. I live in Harrisburg in a house with Brian, Todd, Ron, Michael, and Tim. Four people come in to help. They don't live there. They help plan, remind people about things . . . just help out. Everyone who lives in the house works.

I work in Mechanicsburg at CIT (Center for Industrial Training). I like my work . . . I pack boxes, sweep, help people. I have good friends at work. I take four buses to work . . . two over and two back. I like taking buses. I know how to take buses in Pittsburgh, Harrisburg, and Washington. I take Greyhound buses, too. I like to fly.

My church is the Linglestown Church of God. I go every Sunday. The church van picks me up. At church I sit with Carol Grauel. Her husband is Jim. He sings in the choir. They are my church family. I love going to church. I love God. He is in Heaven, so is Jesus. And my first mom. Mom (Ginny Thornburgh) is my second mom.

I want to live somewhere else . . . with more room, not so many people. I want more friends my age. I want to do more things . . . shopping at malls and stores, baseball games . . . the Phillies . . . I like the Pirates, too . . . hockey games and the Hershey Bears.

I know how to get up by myself. I know when to pack my lunch. I know how to take a bus. I do a lot for myself. Sometimes I do need staff. Sometimes I don't need staff at all.

Note: Since this interview with Peter in the spring of 1991, he has moved to a more independent setting, sharing an apartment with one man and staff.

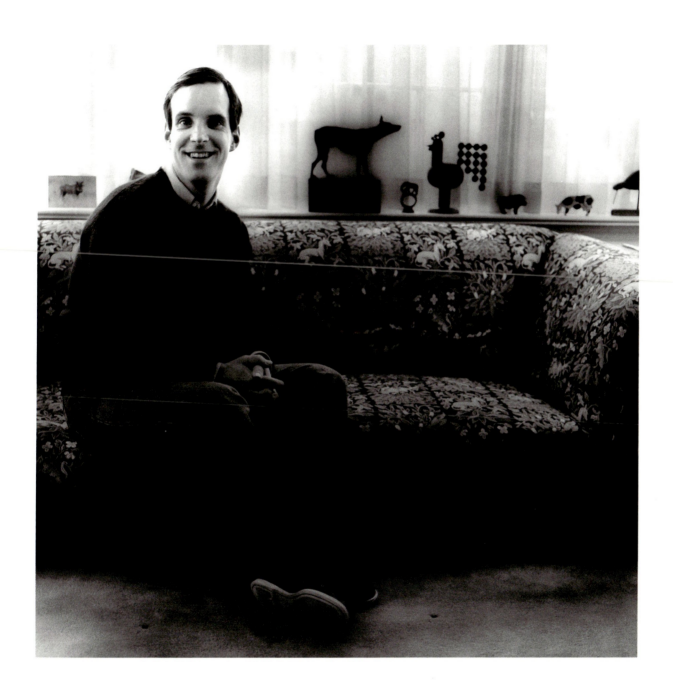

PETER THORNBURGH lives in Harrisburg, Pennsylvania, and works in nearby Mechanicsburg at the Center for Industrial Training. Peter sustained brain injury when he was in an accident at the age of four months. This portrait was made in Washington, D.C., at the home of his parents, Dick and Ginny Thornburgh.

DR. MELVIN E. SCHOONOVER

When I came along sixty-six years ago, very little was known about disability. People who were disabled were often hidden away. The center of my world on our Indiana farm was the living room, where I stayed. I rarely went out, except to the hospital. School was out of the question; my mother and aunt taught me to read and write. I was a voracious reader—went through most of the books at the library in town. A friend of the family gave me an encyclopedia; I went through that. High school brought a structured tutorial program — rather difficult, as I had neglected math and science up to that point.

If it hadn't been for two people I probably wouldn't have gone to college. Charles McCarty, the minister of our Baptist church, and Bertha Bostick, the vice principal of the high school, knew I should go to college, in spite of my doctor's forecast of life as an invalid. So I applied to the twenty-three colleges in Indiana—got twenty-two "no's" and one "maybe, we've never had anyone like you — how would it work?" That "maybe" became "yes" after I met with the admissions board and figured out how it would work. So I got my college education at Wabash College in Crawfordsville, Indiana.

During my junior year, I began to think of becoming a minister in the Baptist church. My senior year I wrote to the eleven best seminaries in the country. A familiar thing happened; all but one rejected my application because of my disability. Union Theological Seminary in New York City gave me a qualified "maybe . . . never had anyone like you before." Union really was unsure, and, in fact, I wasn't ready; so I worked for two years as a medical secretary. I was paid the fantastic sum of $35 a week, had my own apartment, my own independent lifestyle. I continued studying (at the then Butler School of Religion), and when I went to New York to meet with the dean of Union, he decided to accept me. So, later, did the secretary to the dean of students. After a long friendship, turned courtship, she became my wife.

My first church as a minister was a small church in Harlem, where I stayed for ten years. We lived in the "projects," and I ultimately initiated a program to save our neighborhood from urban renewal. I am proud to say that a public housing project in Harlem bears my name.

After that church, New York Theological Seminary hired me to design special programs for storefront pastors with limited education. Then they asked me to become the academic dean. I served for nine years. From New York I went to an upper-middle-class congregation in Wayne, Pennsylvania. That was not for me, so I gave that one up and did some soul-searching about my career and about my future.

My future was in Miami. I came in 1983 and founded the South Florida Center for Theological Studies. My goal was — is — to prepare people for cross-cultural ministry and to be a resource for the various ethnic groups in South Florida. I have a strong sense of providence. The ethnic diversity of that little church in Harlem certainly prepared me for living in Miami.

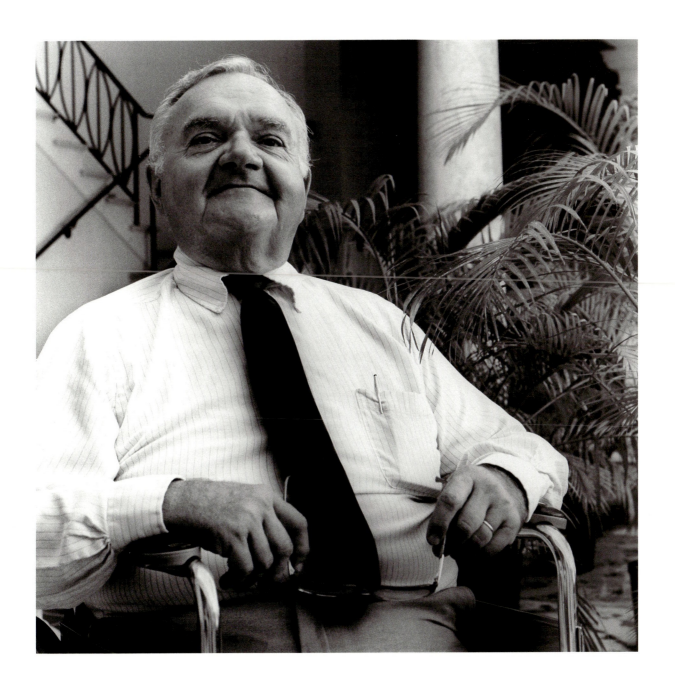

DR. MELVIN E. SCHOONOVER is the president of South Florida Center for Theological Studies in Miami, Florida, where he lives with his wife. Their daughter lives in California. Dr. Schoonover was born with osteogenesis imperfecta, which causes the bones to be extremely brittle and to break frequently.

So what do I say about the life of Mark Shepherd? I've been in the army. I've been married and divorced and am still involved in raising three kids . . . two sons and a daughter. For three years I was a police officer in the San Francisco Bay area.

I loved police work! By nature I'm outgoing . . . enjoy meeting and working with people. I did a lot of that as a patrolman. Another great aspect of that work was that it gave me the discretion to employ the spirit of the law or the letter of the law, according to my assessment of a situation. There is a large gray area in human circumstance. You run into that area a lot in police work. Often you walk into a situation where you have to make a judgment that will have serious consequences for the people involved, yourself included. And very often, it has to be a quick judgment. That's quite a challenge, and I guess I thrive on challenge. Police work does have the potential for developing a pretty negative attitude toward life. You see some very negative sides of society. That's another challenge . . . to see people doing their worst, deal with it, then let it go. But you must disregard the negative and embrace the positive. Otherwise you become bitter.

You could say all the above about disability. Now there's a big gray area! Everyone has a different definition, a different view of disability. It's all according to your own understanding of who you are and where you are. You have to make judgments and be prepared to act on them. And God knows there's potential for developing a negative attitude . . . as a result of the disability and the way you're treated by society as a result of it. So you deal with the negative stuff, let it go, and embrace the positive. And I'm talking about a day-to-day challenge. Having a physical disability gives a person a new slant on what's important. I strongly believe that life is what you make it, not what it makes of you.

Since I was injured there have been some inevitable changes in my life, but a lot about me is the same. One thing that hasn't changed is my competitive spirit; I've always been, still am, an avid athlete. Disability does not diminish involvement and enjoyment of athletics or the positive effect of competition. It certainly has prepared me for life's challenges, personally and professionally.

I'm a very busy, happy man, with a very full, interesting life. I'd be happier, though, if I didn't have to work so hard to convince people that this is true.

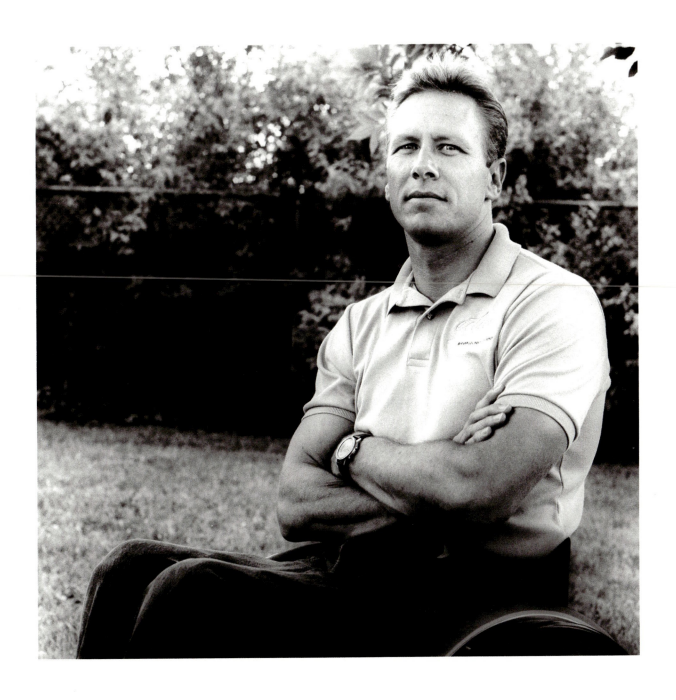

MARK SHEPHERD is a California native who currently lives in northeastern Ohio, where he is director of consumer marketing for Invacare Corp. He sustained a spinal cord injury in an automobile accident.

RUTH ELIZABETH (Bette) KNAPP

I've heard a lot of disabled people complain about their parents . . . too over-protective, too pushy, etc. My parents were resourceful, intelligent people who were determined to do what was necessary to help me meet my potential as a person. They understood the trauma of a healthy, active child whose body changes drastically and made sure I had a childhood very much like that of other children. When I could no longer walk, Mother built me a wheelchair from a folding auditorium chair and four tricycle wheels . . . and we went everywhere. I was never isolated . . . all the kids played at our house. I went to public schools in West Hartford, Connecticut, and Pittsburgh and spent my last three years in a private school in Hartford. My mother came to school to help me. Teachers, principals, kids were helpful. Of course I was different, but not set apart.

From high school I went to Smith College. There, as in high school, I never wanted extra help, didn't want to be set apart from the other students. For example, although it took me longer to write, I never took extended time for exams. I think that helped my rapport with the other students; I really was one of the gang.

At that time there was no financial aid for disabled students, so Mother was my aide at school. We commuted . . . Smith during the week, home to Dad weekends. At Smith I was very active, even started some campus organizations. In 1951 I graduated with honors in political science.

My life changed drastically when my mother died in 1970. My dad had died earlier. I was completely alone. About this time the advocacy movement for disabled people was taking shape. For the first time I saw myself as a member of this minority and knew I had to be involved. I chose the church as my venue. For the next ten years my time and money were spent on "raising the conscience" of the world church. Until then disabled church members were largely ignored; there was no thought given to making the church a more welcoming organization to those of us with special needs. I am proud that I was the author of a statement on the relationship of the church to disabled people that was adopted at the 1977 Nairobi Assembly of the World Council of Churches. I traveled alone to that conference. I consider that time and money important investments in myself, as well as in the future of all people with disabilities. And it helped prepare me for my present job.

As head of the Department of Programs and Services for the Disabled at Lincoln Center, I am concerned with accessibility for all patrons and education and mainstreaming of disabled and nondisabled minority kinds. After all, the arts are an essential part of our lives . . . our education, our personal and spiritual development. They are not a luxury; they are a necessity . . . for *everyone*.

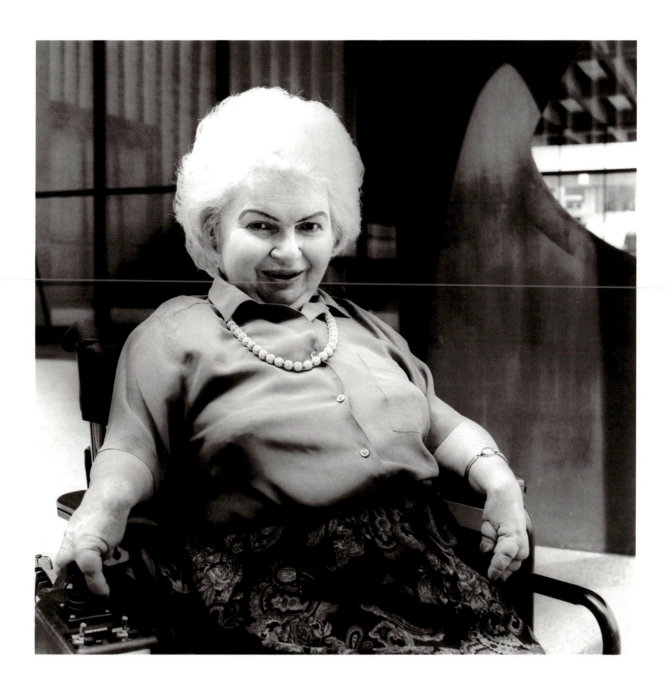

RUTH ELIZABETH (Bette) KNAPP lives in New York City, where she heads the Department of Programs and Services for the Disabled at Lincoln Center for the Performing Arts. Bette has had rheumatoid arthritis since she was three years old and has used a wheelchair since the age of six.

I was born in Wadesboro, North Carolina. My great-grandfather, Coleman Gaddy, and his wife were slaves. His wife was sold after the birth of their first child, who was my grandmother. Then my great-grandfather and his child were taken to the "big house," and my great-grandfather was used for a breeder. He fathered forty-five children by the slaves. He kept in touch with all of them, and I knew all of them, too.

My Grandfather Bennett was a slave, too. I don't know my father's side of the family as well as I do my mother's; however, I do know that Grandfather Bennett was the minister at Rock Ford East Baptist Church, across the creek. My father and mother had ten children; five of them are alive today.

My father told us to "get learning." He said, "Nobody can rob you of your knowledge." So I graduated from high school and attended Shaw University, where I studied education. After college I was married. Then I taught school. My first assignment was a one–room school where I taught beginners through the seventh grade.

I studied nursing by correspondence and started working as a nurse-midwife after the youngest of our six children started school. I delivered my niece's first child and my daughter Rubye's first child. It was a most rewarding career; I retired at age sixty.

Now I can't talk about my life without talking about my late husband, the Reverend Thomas J. Tillman. He was twenty years my senior . . . a dedicated educator and minister, a devoted husband and father. He reared our children without raising his hand or his voice, except in warning of danger. We had thirty-six beautiful years together.

My children have cared for me since his death. They have been so good to me. But they work and have their own families to care for. Older people have to help themselves. That's why I work with Washington Inner-city Self Help. We work with all ages for all causes. A group of us worked for changes in the building I lived in before moving here because it wasn't accessible to people in wheelchairs. We were successful and now it is much easier for them to get into the building.

On June 12, 1991, I was ninety years old, and I count it a blessing to have five generations of my family present. I count it a blessing to have my mental faculties. God has been so good to me, and I've always tried to be good to others.

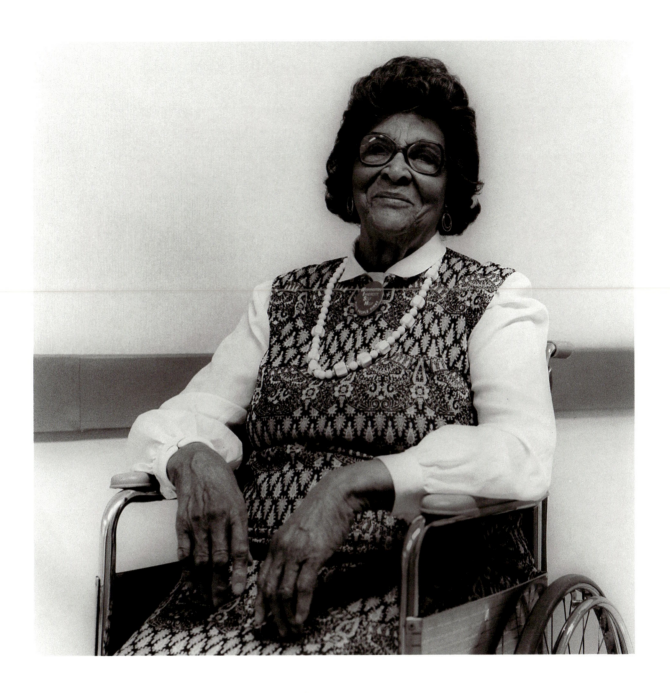

CORA M. BENNETT TILLMAN lives in Washington, D.C., where she is an activist on behalf of people in the inner city, as well as people with disabilities. She has used a wheelchair since 1984, when she was injured in a car accident.

My childhood was nothing extraordinary. We moved around a lot because of my father's job.

I went to college at St. Andrew's Presbyterian College; again, nothing extraordinary. Until I was nineteen . . . then something very radical happened to change my life. I lost my hearing because of medication I was given following kidney surgery.

I spent a difficult, often painful, year back at St. Andrew's, trying to resume my former life. My needs had changed, but St. Andrew's hadn't. Nor had my friends, who were unable to understand. And I couldn't help them; I didn't understand it all myself.

A semester at Gallaudet University made all the difference. What a relief to meet deaf people who understood! I learned ASL (American Sign Language) and I learned that I hadn't really changed . . . just my communication mode. I loved Gallaudet, but I made the decision to return to St. Andrew's and graduated with a degree in psychology.

My graduate degree is in deafness rehabilitation . . . from New York University. At first it was awful in New York. The campus, the whole city, were so inaccessible. But I worked things out, made friends, and ended up having a wonderful year and a half. Living in the (Greenwich) Village was great! I still love New York. My stepmother lives in the Bronx, so I go up every eighteen months or so. We stay in Manhattan until we run out of money, then she goes back to the Bronx and I return to Atlanta.

The NYU placement office found me a job in Rome, Georgia. Rome is a lovely place, but I'm really a city girl, so when a job opened up in Atlanta I moved. My current job is director of the Georgia Interpreting Services Network. I educate consumers about the need for qualified interpreters, and our office coordinates interpreting services statewide. I love my job!

When I'm not working I enjoy taking care of my house and my animals, reading and doing counted-thread cross-stitch. And I'm a loyal (Atlanta) Braves Fan. Oh, and I love to travel. Fortunately, I do a lot of that.

I'm active in the deaf community and serve several organizations. I feel service to one's community is so important for each person. Too often people with disabilities are seen as recipients of help, but not as givers of help.

I must say that I would never make it without my faith, my friends, and my family.

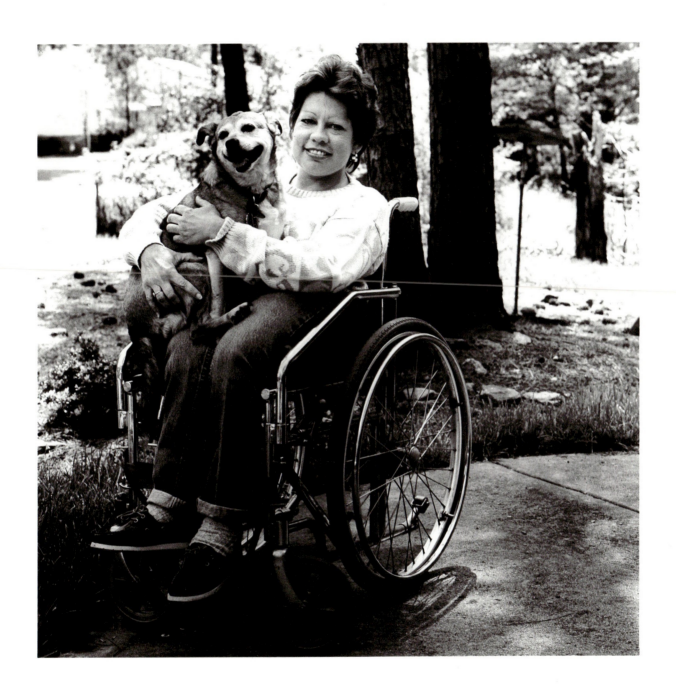

ROBIN TITTERINGTON was born with spina bifida and, at the age of nineteen, lost her hearing as a side effect of medication she was taking. Robin lives in Atlanta, Georgia, where she is director of the Georgia Interpreting Services Network for the Division of Rehabilitation Services of the Georgia Department of Human Resources. She is pictured with her dog, Lucy.

My name is Brynn. Santa Claus bought me a red Corvette for Christmas. Push a button on the steering wheel to make it go. I like to play with my horsie. I have a Whiz Wheel at Nannie's (Brynn's maternal grandmother). It has a handle and goes, "Brooooooom-Brooooooom!" I live here with my mom; I go to Daddy's some, too. When Mommy is at work I stay with Laura.

Brynn's mother, DARLENE CONN — I knew when Brynn was born that he was a special child. I just didn't know how. That helped when he was hurt. I've never treated him like a baby. He's been through a lot . . . the accident . . . recently his father and I divorced. He's come through it exceptionally well. I know kids are resilient, but it's something more than that. He's very independent and outgoing. What scares me to death is that he's not scared of anything.

I just learned about a program in our county for disabled kids. But as soon as possible I'd like to mainstream him. I'd really like to put him in a daycare center that's certified for disabled children, as well as able-bodied kids, but I don't know what the cost would be. Of course I want Brynn to be as "normal" as possible. I know Brynn can do anything. If he puts his determined little mind to it, he *can* do it!

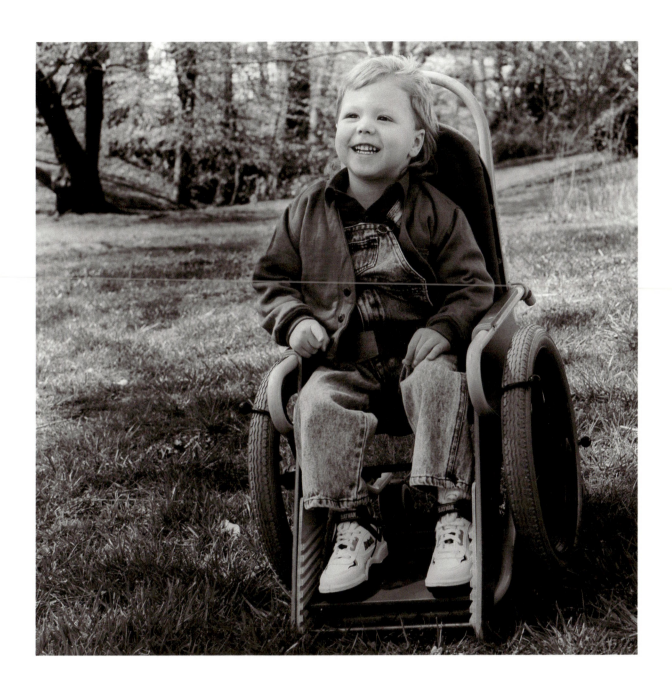

BRYNN CONN lives in Marietta, Georgia, with his mother. He sustained a spinal cord injury in an automobile accident when he was eighteen months old.

AFTERWORD

The fifty-two portraits and personal essays in this collection are not about unusual people. Each is somebody's son or daughter, mother or father, brother or sister, husband or wife, neighbor or friend. While some may be recognized beyond their immediate community, most will not. Yet each is unique. Whether blind or deaf, partially hearing or visually impaired, mentally retarded or intellectually brilliant, wheelchair or cane or crutch dependent, or impaired in a way that doesn't show, each hopes to be viewed as an individual.

These individuals were selected by photographer Lynda Greer to commemorate the inclusion of the newest minority within that experiment in democracy which began as our nation was created. Those patriotic men who established this United States of America were fired by a passion for freedom, self-determination, and independence. And fortunately for those of us not originally included in their deliberations, the documents they crafted have been stretched to extend that vision of democracy far beyond the boundaries of their limited expectations. And in this volume Lynda Greer celebrates a new reality: Past declarations of human rights and dignity are now defined to include Americans with disabilities.

Until recently the development of assorted impairments moved millions of us away from lives of productivity and into stagnation and roles of dependency. Too many of us were treated as if we had become second-class citizens. But that has slowly changed with bipartisan support at all levels of government and evolving sensitivity in all segments of society. Now, with passage of the Americans with Disabilities Act, inclusion is finally the law of the land.

On July 26, 1990, as President Bush signed this landmark civil rights bill into law, he called it a sledgehammer that the nation will use to knock down those segregating walls that too long "separated Americans with disabilities from the freedom they could glimpse but not grasp."

Time-honored social policy had consigned the unfulfilled dreams and potential gifts of tens of millions of Americans to fade unnoticed, hidden behind a fog of fears and negative stereotypes. Ms. Greer's lens cuts through the dusty clouds of ignorance and prejudice to focus on the joy and contributions made by ordinary people who live day to day with assorted impairments. She brings fresh insight and clarity to the impairments. She brings fresh insight and clarity to the challenges that lie ahead.

And those challenges are real. An increasing flood of people are being salvaged each day through medical advances. These individuals are routinely surviving those traumas that would have killed their grandparents and severely limited their parents' ability to live productively. Evolving technology and knowledge can move those currently "handicapped" by outmoded myths and apprehension into lives with meaning and potential. These Americans hope to find and fill meaningful roles in their communities. And each year more of them are doing so. This volume offers us all a provocative look at a few people who are a part of that shifting social landscape.

The personal insights about life's experience beyond the limitations of impairments radiate a vibrant vision of expanding opportunities and possibilities. Previously the world lacked the resources and knowledge to glimpse the potential that lay hidden behind human vulnerability. Reality tosses us about in the river of life, polishing and reshaping us. What makes us each unique becomes ever more precious as we survive those traumas that test our strength of spirit and will. Lynda Greer glimpsed the miracle of rehabilitation and rebirth through her lens and happily determined to share the portraits she collected.

A critical call to action was issued from a raised platform on the South Lawn of the White House as thousands watched. This ceremony followed a struggle that joined a diverse collection of advocates for human dignity into a multitude with one voice. All joined in urging passage of the Americans with Disabilities Act. But they also understood that the lens through which the country evaluates its strengths must be shifted. The president read these words: "America welcomes into the mainstream of life all of our fellow citizens with disabilities. We embrace you for your abilities and for your disabilities, for our similarities and, indeed, for our differences, for your past courage and future dreams."

All of us may eventually come to marvel at our shared aspirations and celebrate that rich diversity which has always been our greatest national asset. The challenge is renewed as each citizen recognizes the truth of our proud heritage:

We hold these truths to be self-evident, that all Americans are created equal; That we are endowed by our Creator with certain inalienable rights; and among these rights are life, liberty and the pursuit of happiness!

Mary Jane Owen, M.S.W.

Ms. Owen is executive director of both Disability Focus, Inc., and the National Catholic Office for Persons with Disabilities in Washington, D.C.